IMAGES
of America

CLARK

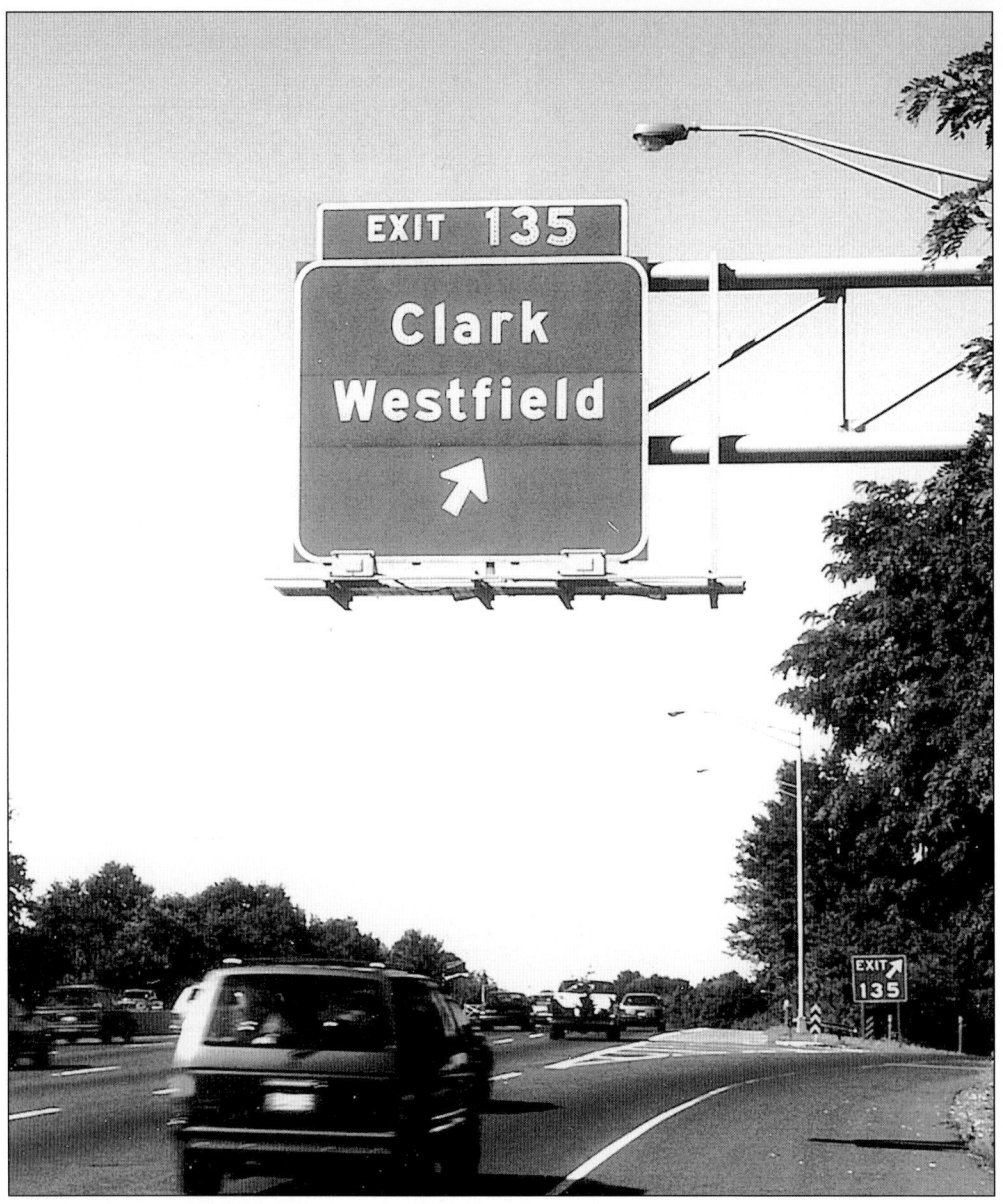

CLARK, NEW JERSEY. Shown is a view of Exit 135 on the Garden State Parkway.

Brian P. Toal

Copyright © 2003 by Brian P. Toal
ISBN 0-7385-1305-9

First published 2003

Published by Arcadia Publishing,
an imprint of Tempus Publishing Inc.
Portsmouth NH, Charleston SC, Chicago,
San Francisco

Printed in Great Britain

Library of Congress Catalog Card Number: 2003107447

For all general information, contact Arcadia Publishing:
Telephone 843-853-2070
Fax 843-853-0044
E-mail sales@arcadiapublishing.com
For customer service and orders:
Toll-free 1-888-313-2665

Visit us on the Internet at www.arcadiapublishing.com

This book is dedicated to the memory of the citizens of Clark who have gone before us. To my father, the late James J. Toal, and to the late Joseph E. Alacchi Jr., Charles E. Driesens Jr., Edward S. Ayers, and Peter Esposito, who set me on the pathway of exploring Clark's historic past.

Contents

Acknowledgments		6
Introduction		7
1.	The Farmers	9
2.	The Mayors	23
3.	The Police	43
4.	July 4, 1971	51
5.	The Clark Volunteer Emergency Squad	57
6.	The Clark Volunteer Fire Department	67
7.	School Days	79
8.	Our Town	87
9.	Portraits of Distinction	107
10.	Fallen Heroes	117

Acknowledgments

I wish to extend my deep appreciation and eternal gratitude to the following people for their assistance in the creation of this book.

This book became a reality because of the support of the following: Kathleen Toal, Kevin Toal, Lois Petrilak, the Clark Historical Society and its dedicated membership, Mr. and Mrs. Robert Yelenovsky and family, Maureen Wilkinson and the Clark Public Library staff, Bernie and Carole Hayden, Frank Klett, Mr. and Mrs. Fred Asal, Les Bartle, Mr. and Mrs. Joseph Olterzewski, Gus Granrath, Mike Versusky, Mr. and Mrs. Carl Frank, Mr. and Mrs. William T. Fidurski, Mr. and Mrs. Joseph Deacy, Mr. and Mrs. Joseph David, Mr. and Mrs. Bruce Larrimore, Kathleen Leonard, Terri Mazzarella, Edie Merkel, Mary Vickery, Marietta Schott, Linda Cohen, Nicholas Manno, Lisa Schmid, Ivan Ordonez, Leigh A. Messinger, Mr. and Mrs. Greg Young, Mr. and Mrs. John Kolmos, Kenny and Dolly Hark, Jimmy Calavano, the Deara family, Steve Deara, Sergio Rossini, Ron and Joyce Hoehn, Charlie and Mary-Jo Grimm, and Henry and Florence Metz.

For allowing photographs of their loved ones to be a part of this book, thanks go to the following: the Bosze family, Grace Driesens, Mrs. William Maguire, Sue Bauman, Eleanor Warren, the Muth-Hawley families, Gary Clark, the Bartell family, the Schieferstein family, the Esposito family, Nancy Peterson Godfrey, Hannah Kaufman, Mr. and Mrs. John Conway, the Harrison family, Roseann Nelson, Constance Brewer, Laurie Flood Sheldon, Francis Garafola Miele, John and Vicki Cooke, Edward Ward, Virginia Robinson, Joyce Morway, Edith Liebowitz, David Toma, Bill Duffy, Mr. and Mrs. Joseph Rybak, Dr. and Mrs. Lawrence Vargas and family, Barbara Keller Gallagher, the Honorable Sal Bonaccorso, the Honorable Jay A. Stemmer, and the Honorable Thomas A. Kaczmarek. To all those who have helped behind the scenes, I sincerely thank you.

A big thank-you goes to William Duffy, retired police captain, who should be credited for Chapter Nine, Portraits of Distinction, which he created for the Veterans of Foreign Wars post and has allowed for use in this history of Clark.

Introduction

The words "Clark, New Jersey" evoke the heartfelt emotions of home. This small, quiet town is located in central New Jersey along the Garden State Parkway at Exit 135.

The township of Clark was the hunting and fishing grounds for the Lenni Lenape Indians, who originally inhabited the region. The territory that would become Clark was nothing more than an agricultural paradise of fertile farmland and vast open space. With the passage of time and the arrival of the European settlers, this quiet region would become an integral part of the birth of the nation. As the English colonists chose to sever ties with England, what would eventually become Clark began as the crossroads of the American Revolution. This is evidenced in the Battle of the Ash Swamp, which is the present-day Oak Ridge Golf Course. This historic battle was fought on June 26, 1777, and was the very first defense of the Stars and Stripes after the Continental Congress adopted the Flag Resolution on June 14, 1777. As America's forefathers won their independence from British rule and established the United States, the territory of Clark remained a part of Spanktown, now Rahway, until 1864.

As the nation entered the mid-1800s, the area of Clark became incorporated into the city of Rahway as its Fifth Ward in the year 1861. However, in March 1864, at the height of the Civil War, the local farmers led by Robert A. Russell, William Bloodgood, and William H. Enders declared their independence. They felt that their tax dollars were being spent in other areas of Rahway.

The 356 residents of Rahway's Fifth Ward declared their freedom and named their new community Clark Township to honor Abraham Clark, a signer of the Declaration of Independence, who had lived in the area.

In 1864, the area consisted of fertile farmland with agriculture as the main source of income. Clark did have two other types of industry within its borders, the Taylor & Bloodgood felt mill and the Helca gun powder mill.

Clark remained a rural farming community well into the 20th century. When state Highway No. 4, later to be known as the Garden State Parkway, cut through the sleepy farm community in 1946, the township of Clark was transformed into a thriving suburban community. The residents began to witness their open land disappearing as the older farmers began to fade away with the passage of time. Farming was a 24 hours a day, seven days a week occupation and the farmers' heirs chose to pursue other careers. The farmland was sold off to developers who transformed Clark from a rural farm community to a thriving suburban township, which we call our hometown.

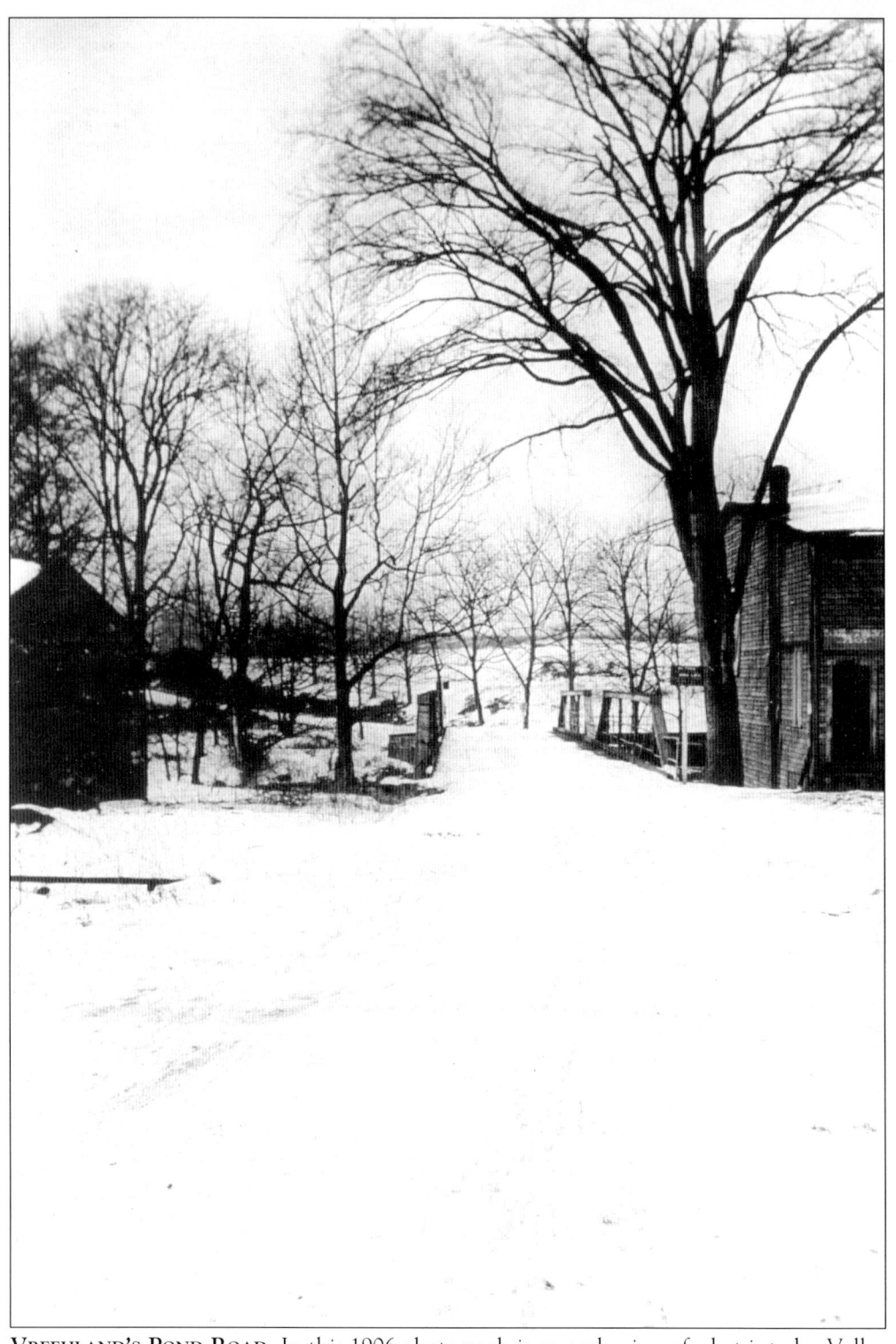
VREEHLAND'S POND ROAD. In this 1906 photograph is an early view of what is today Valley Road at the Jackson Falls Bridge.

One
THE FARMERS

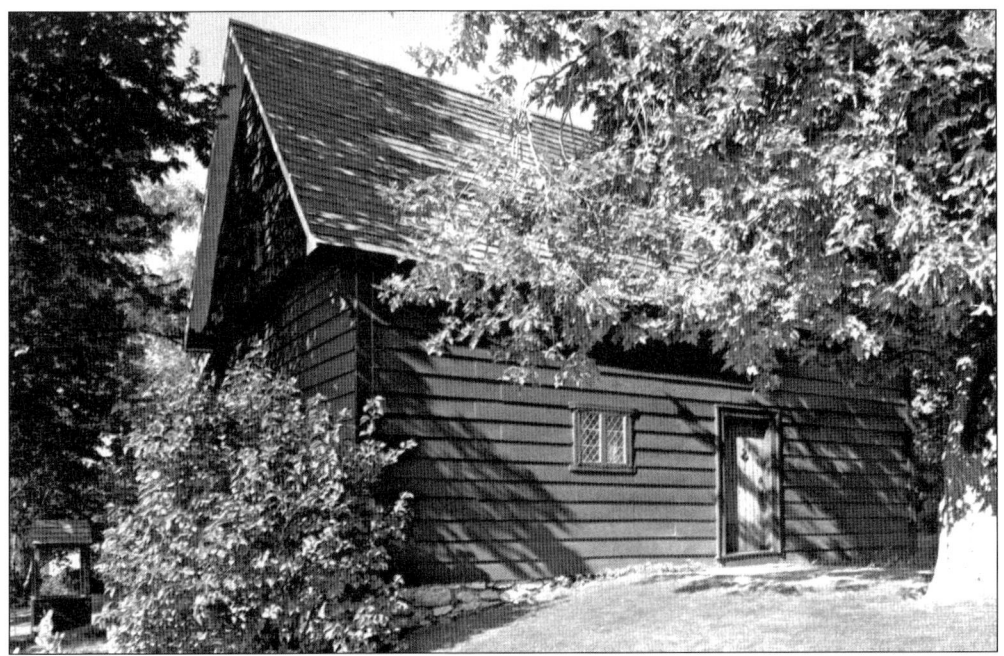

THE DR. WILLIAM ROBINSON PLANTATION. The Dr. William Robinson Plantation was established in 1690. This was Clark's first farm and homestead. It was restored in the mid-1970s by the Clark Historical Society.

HOMESTEAD FARMS AT OAKRIDGE. The largest farm in Clark was founded in 1720 by the Bowne family. It is presently used as Union County's Oak Ridge Golf Course.

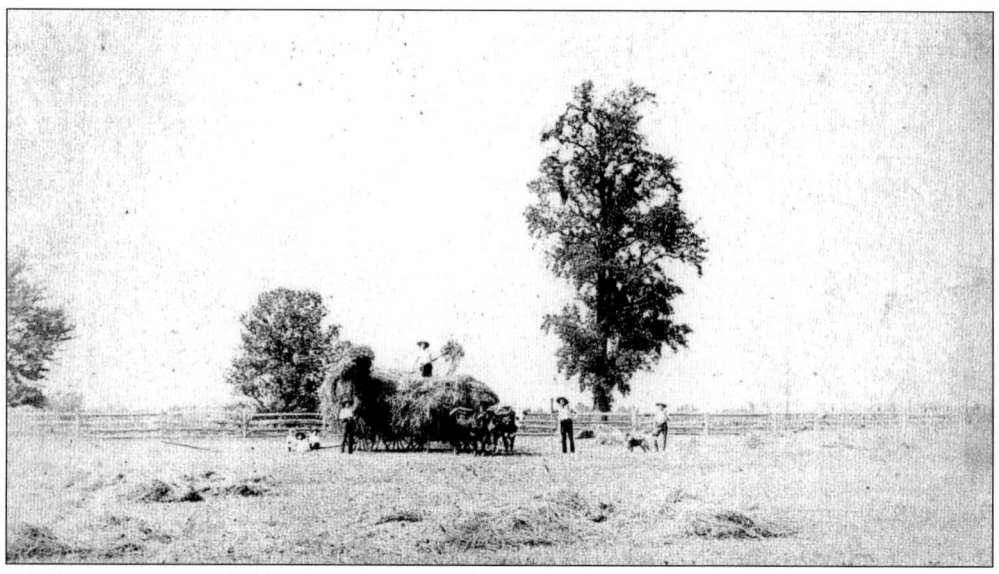

BALING HAY. Seen tending to chores at Homestead Farms, farm manager John Fagan bales hay to feed livestock in this c. 1880s photograph.

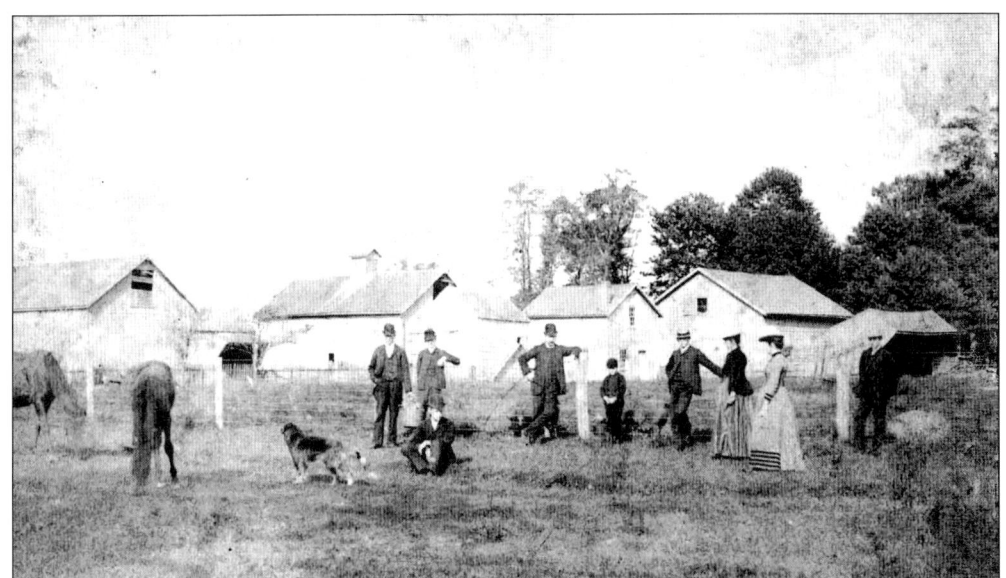

LIVING QUARTERS. The outer buildings of Homestead Farms were used for the farm hands' living quarters as well as keeping livestock. Shown in this c. 1880s photograph, these buildings were located near the present-day practice green of the Oak Ridge Golf Course.

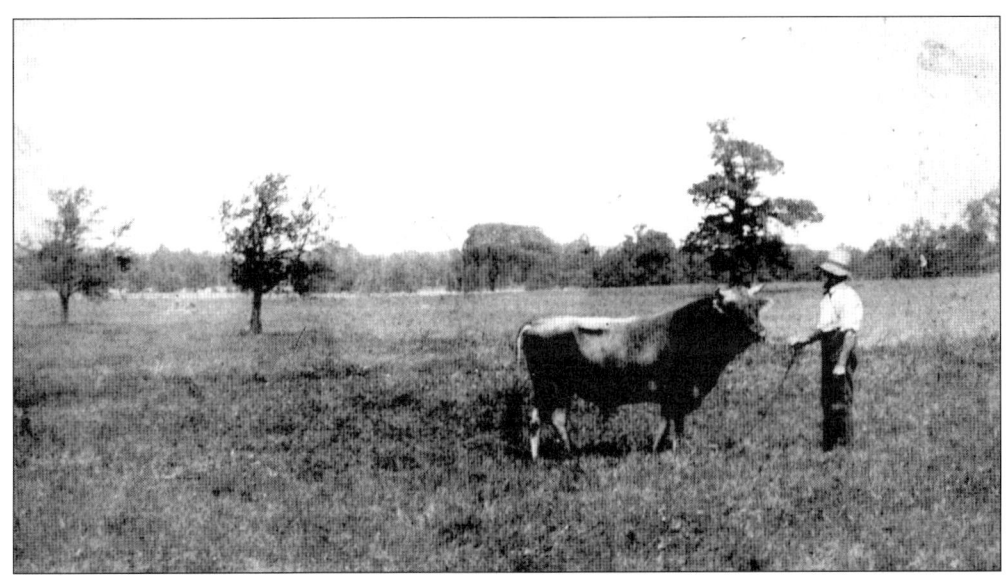

A PRIZEWINNER. The Homestead Farms prize-winning bull, Thor, is seen in this 1880 photograph.

THE PETERSEN FARM C. 1940. Located on Lake Avenue, this was the fourth-oldest farm in Clark, c. 1778.

THE VAIL-PETERSEN FARM. The Vail-Petersen farm is seen in this c. 1890s photograph. At this time, the Engelhardt family lived on the Lake Avenue farm.

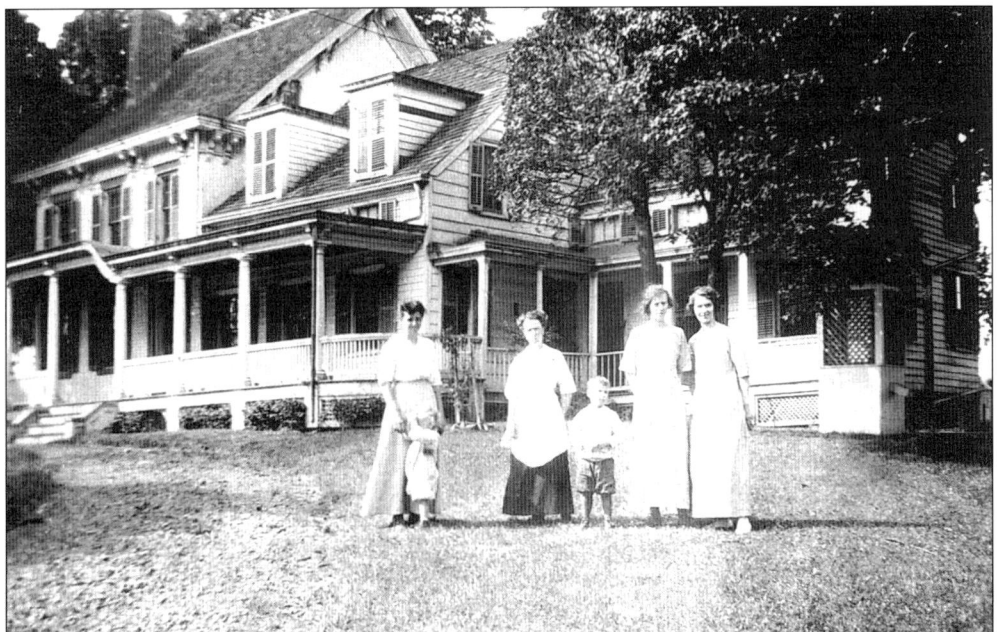

THE HARTSHORNE ESTATE. This 1740 estate, situated at 999 Lake Avenue, was the home of the Hartshorne family. The estate and farm extended from Lake Avenue south to the Middlesex County border, near the present-day Clark pool.

THE LAMBERT DAIRY FARM. One of the most prominent dairy families in central New Jersey, the Lamberts owned and operated a large dairy farm in Westfield on what is today Lamberts Mill Road. Albert Lambert, the youngest of the Lambert children, married the daughter of Levi Darby, who owned a small farm on Madison Hill Road in Clark. Lambert transformed the small farm into Clark's most successful dairy operation. The farm was located on present-day Elisa Lane.

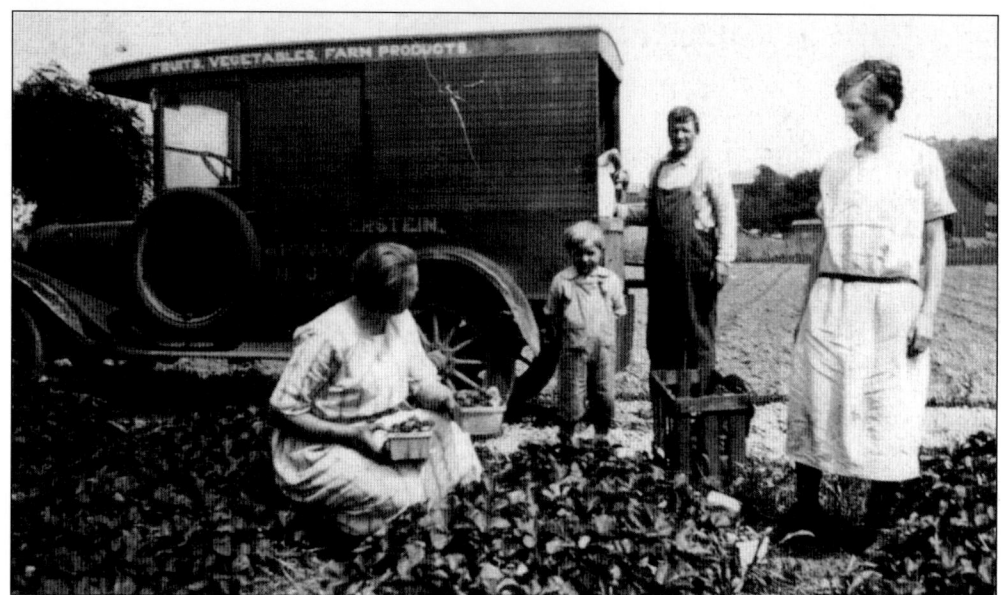

THE SCHIEFERSTEIN FARM. Frederick Schieferstein Sr. began operation of his own farm in 1903 on Madison Hill Road. In this 1930 family photograph are, from left to right, Nellie (Weiss) Schieferstein, Jim Schieferstein, Fred Schieferstein, and Mrs. Schieferstein (Frederick's wife).

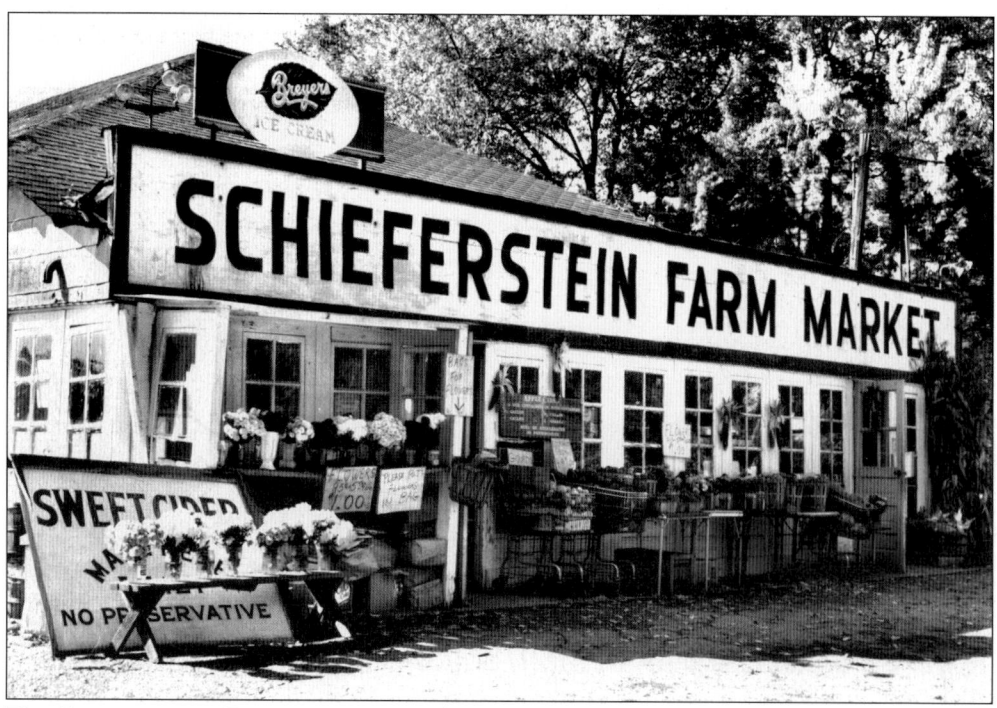

THE SCHIEFERSTEIN FARM MARKET. With changing times, the Clark farmers began new ways to sell their produce. The Schiefersteins were the first to open a roadside stand. The Schiefersteins' first stand was built in 1940. Destroyed by a fire in December 1995, it was rebuilt and became Clark's only link to its farming past.

THE TURKEY FARM. The Vail "turkey farm" is located at 1202 Lake Avenue. Affectionately known as the "turkey farm," this old house was constructed in the mid-1840s. It was home to Israel Vail, an original settler of the Clark area. This house and farm are best remembered as one of the largest turkey farms in the area during the 1930s and 1940s.

THE ESPOSITO FARM. Originally the DeCamp farm on Madison Hill Road, this farm was acquired in 1913 by Anniello Esposito. He transformed it into one of the finest vegetable farms in the area. The Esposito farm survived until the death of Peter Esposito on May 29, 2001. This brought an end to Clark's last operating farm.

THE TERHUNE FARM. Dating back to the Colonial era, the Terhune farm was situated along Madison Hill Road, in the area that is present-day Terhune, Wendell, and Post Roads. It was known for its fine fruits and vegetables, especially its strawberries.

THE WEIMER FARM. Located at 366 Westfield Avenue across from the high school, this farm was owned by one of Clark's founding families, the Weimers. This large estate began at Westfield Avenue and extended all the way back to what is now Central Avenue. It was known for its famous peach orchards, which were located on present-day Dawn Drive. John Weimer was one of the farmers who helped lead the citizens of Rahway's Fifth Ward into separation in 1864, which led to the creation of Clark Township.

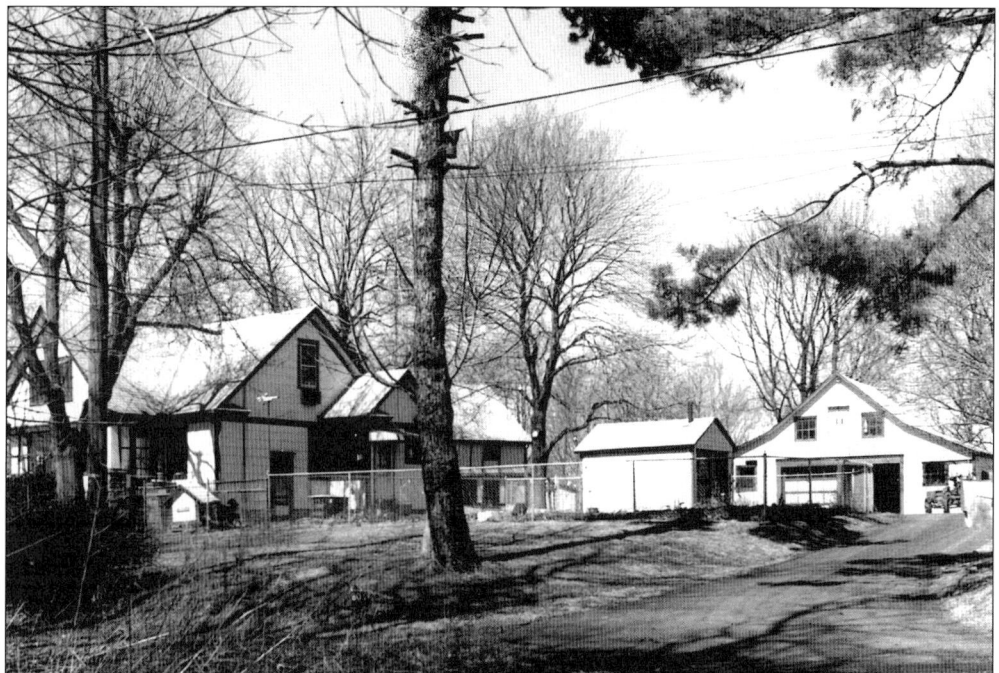

THE FRED SCHWARZ FARM. Located on Old Raritan Road, this little-known farm was originally George Cordes' cow pasture, which was purchased by Fredolin "Fred" Schwarz and his wife, Anna, in the early 1950s. For almost 50 years, they grew the best fruits and vegetables and had one of the finest bee hives in the area. The farm closed with the passing of Fred Schwarz at the end of 1999.

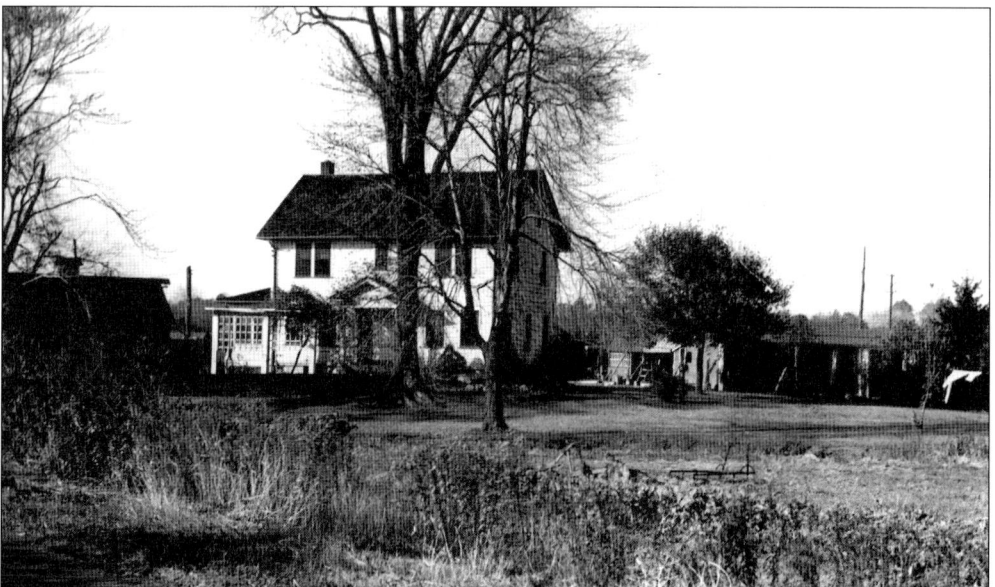

THE GEORGE CORDES FARM. After emigrating from Germany in 1847, George Cordes acquired the land for his farm from the Frazze family of Westfield. The Cordes dairy farm extended from Rahway Avenue to Central Avenue. It was sold to the Villa Construction Company in May, 1952. Today, the property is known as the Terminal Avenue Industrial Complex.

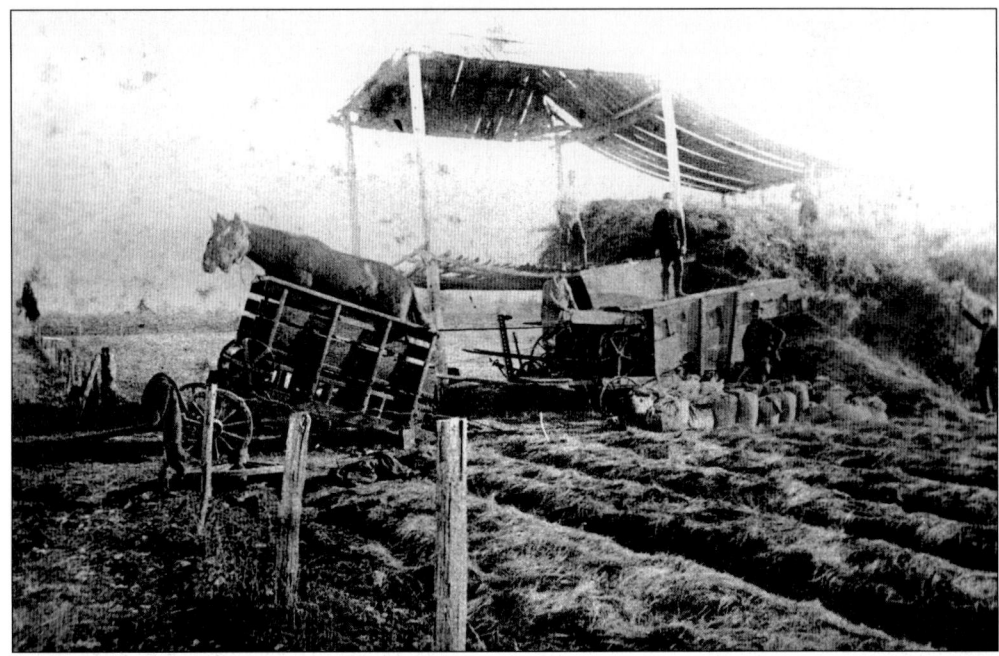

THRASHING HAY. Workers on the Cordes farm utilized mule power to run a thrashing machine, which was used to clean and bale hay. Seen in this c. 1880s photograph, thrashing was one of the many chores tended by the farmers.

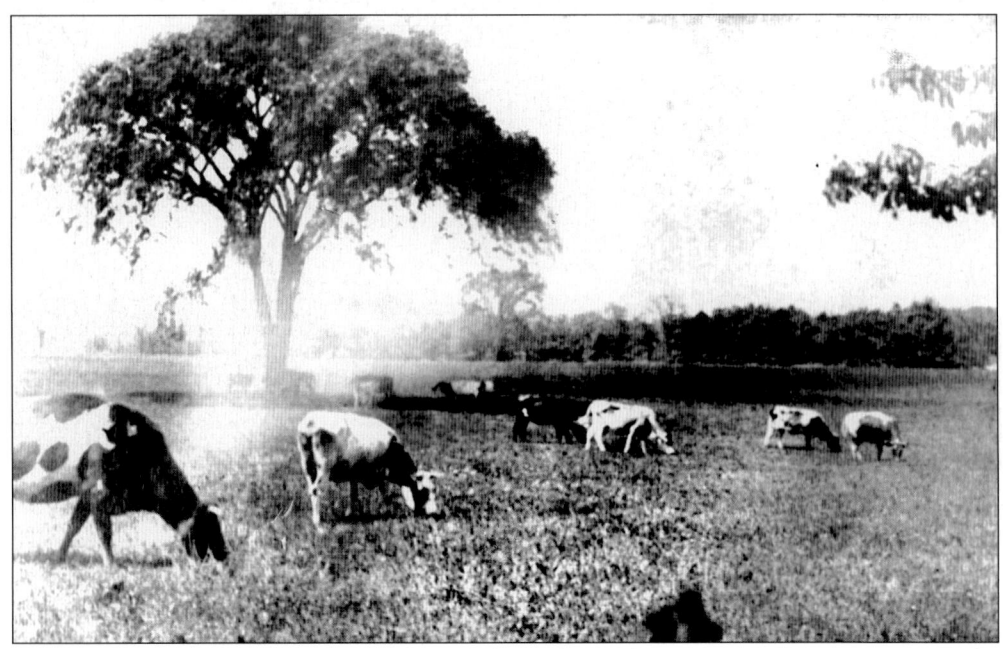

GRAZING COWS. A common scene in Clark in the early 1900s was cows grazing at the Homestead Farm at Oak Ridge along Oak Ridge Road.

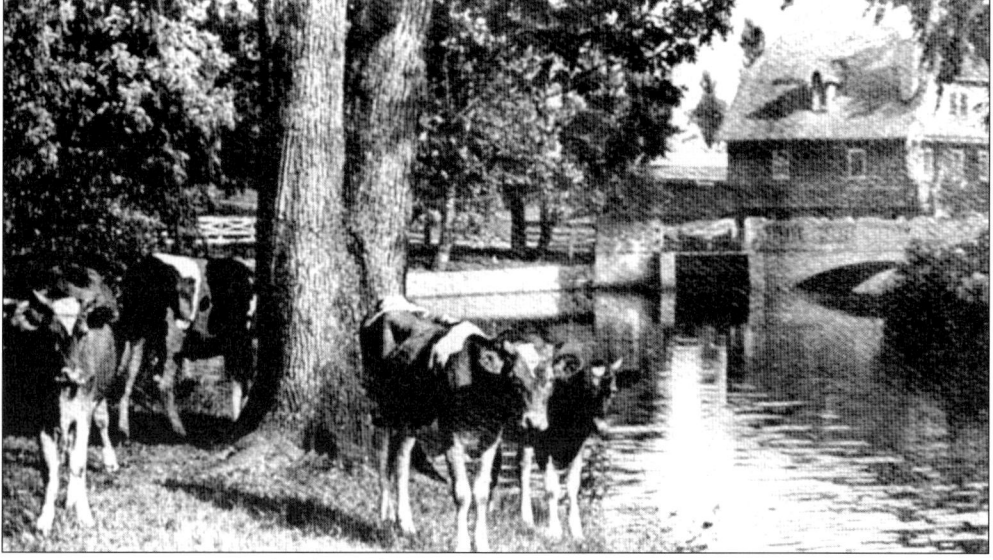

THE REIFEL FARM. Located on the north side of town along Raritan Road, presently the site of Friendly's restaurant, the Reifel farm was in operation for over 50 years, from 1860 to 1910. Known for its fruits and vegetables, most people recall Caroline Reifel's famous German baked goods, which she sold from her front door.

THE OSCEOLA FARMS. This large dairy and horse farm was actually situated in Cranford. A portion of this farm extended into what is now Winfield Park. Winfield was originally entirely in Clark territory, until 1941, when the Osceola farm was sold to the federal government to build housing for shipyard workers in Kearny. The citizens of Clark protested this project, and the township of Winfield was formed by the state legislature.

FAMILY PETS. Animals served many purposes, not only that of the family pet. With the changing times, many new Clark residents and non-farmers would house cows, chickens, and other small livestock in order to bring fresh food and dairy products to their own tables. This occurred in the days before the local grocery stores.

PIGS ON THE KAUFMAN FARM. As with the dairy needs, many Clark farms became smaller in the 1920s. The need to be self-sufficient resulted in the caring for fewer livestock as the farms were downsized.

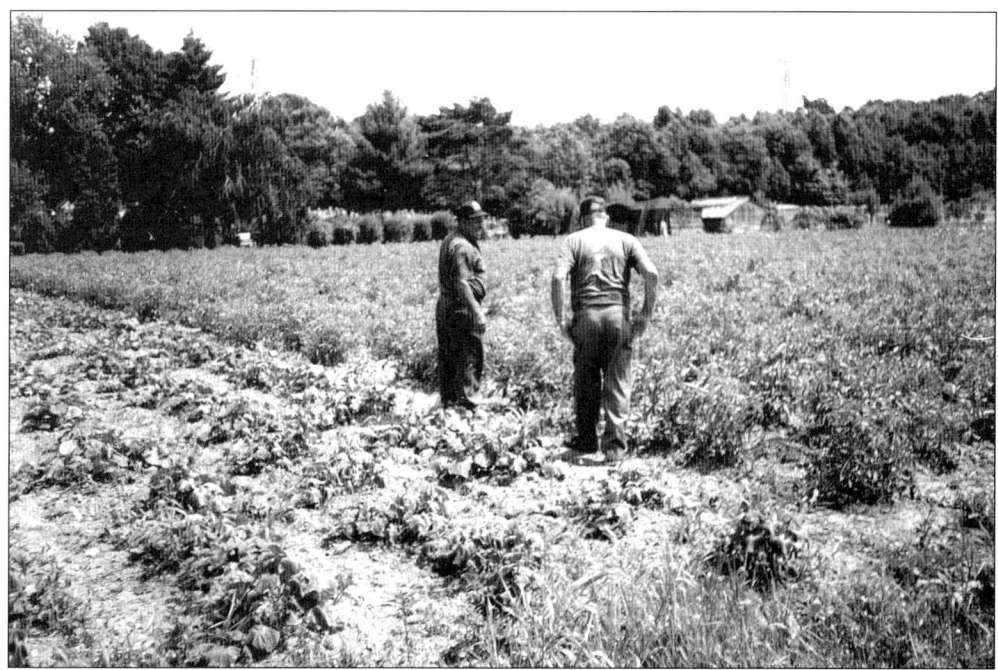

THE LAST FARMERS. Forever captured in time are Peter and John Esposito, shown here picking vegetables in June 2000. That was the last farming year of the Esposito farm on Madison Hill Road.

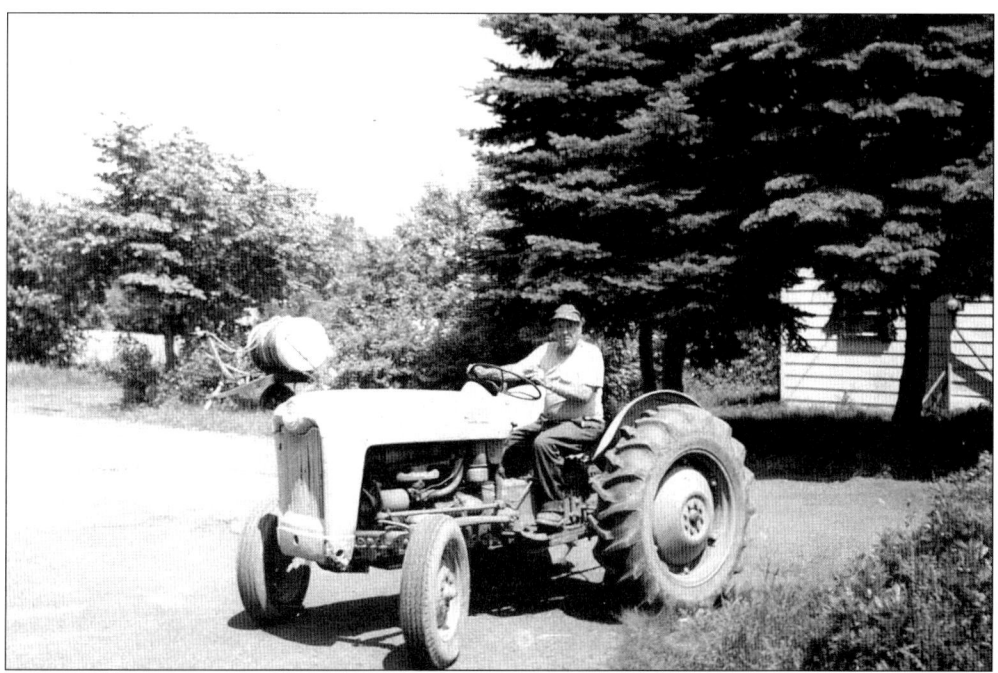

BREAKING GROUND. Peter Esposito tunes up his 1946 Ford tractor as he prepares to break ground for planting in June 2000.

THE LAST COW. Cows were once a common sight in Clark Township. Here, farmer Fred Schwarz; his wife, Anna; and their grandson Frederick are photographed with their cow Blackie. She was officially the last farm cow to live in Clark, on the Schwarz farm, until 1985.

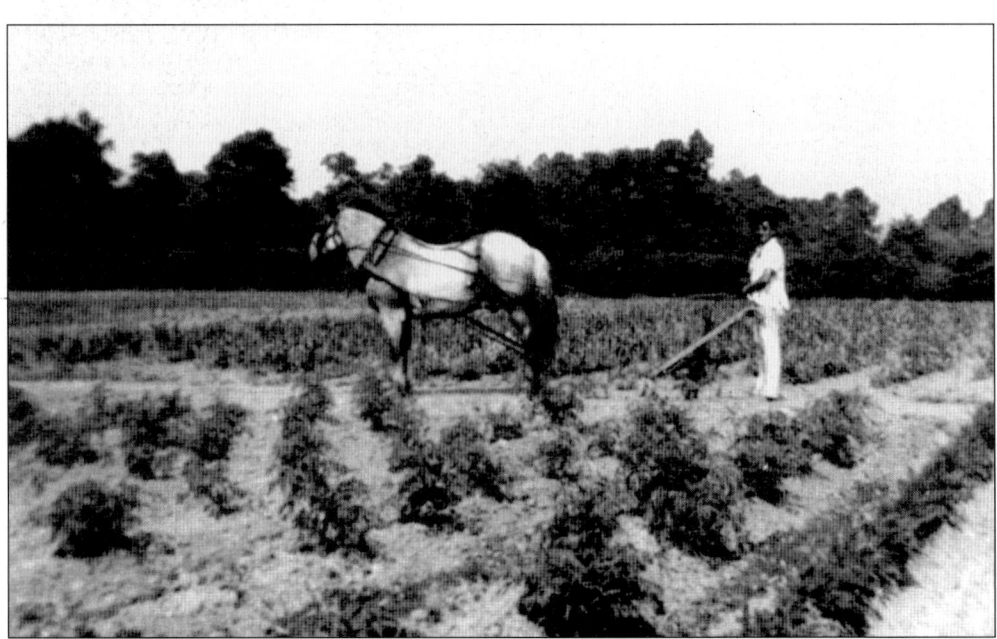

FARM FIELDS. Paul Meissner trowels his fields to allow proper irrigation on his land, which was located along Madison Hill Road near present-day Maybelle Drive and Meissner Way.

Two
The Mayors

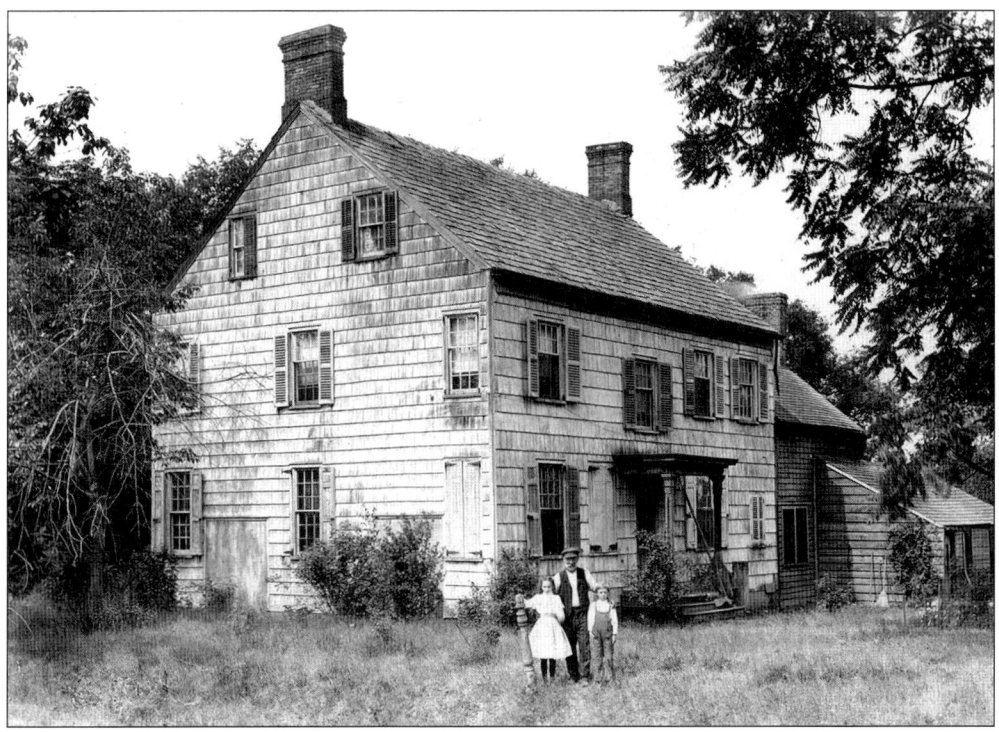

ROBERT ADISON RUSSELL. Robert Adison Russell (November 25, 1825–November 11, 1882) was the first and third mayor of Clark. He served from 1864 to 1867 and 1870 to 1872. A Democrat who was born in Marlboro, New York, Russell lived in Clark on Valley Road. He was a founding father of Clark, and he died at the age of 56 of pneumonia.

WILLIAM EDWARD BLOODGOOD. William Edward Bloodgood (1820–1898) was the second and fourth mayor of Clark. A Democrat, he served from 1868 to 1869 and 1873 to 1875. Born in New York City in 1820, he was the owner of the Taylor & Bloodgood felt mill, Clark's largest factory. He died on October 27, 1898, and is interred in Woodlawn Cemetery in the Bronx, New York.

WILLIAM J. THOMPSON. William J. Thompson (May 9, 1836–January 21, 1919) was the 5th, 7th, and 19th mayor of Clark. He served in 1876 and 1881, and also from 1903 to 1910. A Democrat and lifelong Clark resident, he also served as president of the Clark Board of Education, township clerk, tax collector, and dog catcher. He is interred in Hazelwood Cemetery in Clark.

HUGH HARTSHORNE BOWNE. Hugh Hartshorne Bowne (November 30, 1814–May 18, 1881) was the sixth mayor of Clark. He was a Republican. Born of Colonial ancestry, he served in politics on all levels. A founding father of Clark, and Union County in 1857, he was held in high esteem at the local, state, and national levels of government. A devout Quaker, he died in office on May 18, 1881, and is laid to rest in Hazelwood Cemetery.

GEORGE HARTSHORNE. George Hartshorne (September 30, 1822–December 22, 1910) was the eighth mayor of Clark. He served from 1882 to 1884. He was a Republican. Born in Germantown, Pennsylvania, he lived in Clark, on Quaker Road, better known as Lake Avenue, on his family's estate. He retired from farming and politics and moved back to Pennsylvania in his later years. He died on December 22, 1910, and is buried in his family's plot in Hazelwood Cemetery.

WILLIAM H. ENDERS. William H. Enders (February 25, 1831–November 24, 1904) was the 9th and 11th mayor of Clark. He served from 1885 to 1886 and 1887 to 1889. He was a Republican. Enders was involved in all aspects of the development of Clark. Serving as town committeeman and the longest serving tax collector, he died at the age of 74 in his home on Old Raritan Road on November 24, 1904. He is buried in Rahway Cemetery.

JOHN W. WARD. John W. Ward (1841–1897) was the 10th mayor of Clark. A Democrat, he served from March 12, 1887, to November 3, 1887. He was the manager of the Helca gun powder mill, on Valley Road, and the brother of Caroline Ward Russell, Clark's foremost first lady. On September 20, 1887, his daughter Susanna, age 13, died, and the family moved out of the state. He is laid to rest in Marlboro, New York.

JOHN A. HALIDAY. John A. Haliday (March 25, 1825–September 19, 1905) was the 12th mayor of Clark. He served from 1890 to 1891. He was a Democrat. Born in New York City, he was a longtime community servant and served as a member of the Union County Board of Chosen Freeholders. He was also a farmer. Haliday Street is named in his honor. Haliday died on September 19, 1905, and is buried in his family's plot in Rahway Cemetery.

MARX M. REIFEL. Marx M. Reifel (October 1838–March 30, 1927) was the 13th mayor of Clark. He served in 1892 and was a Democrat. He lived on Raritan Road, near the present-day Friendly's restaurant. After only one year, he left politics to return to farming. He moved out of Clark and retired to his son's house in East Orange, where he died on March 30, 1927. He is interred in Rahway Cemetery with his wife Caroline.

GEORGE CORDES. George Cordes (June 6, 1856–December 12, 1938) was the 14th mayor of Clark. He served from 1893 to 1894. He was a Democrat. A dairy farmer who became involved in politics because of road conditions, he served only two years before returning to his farm. He lived on what is today Terminal Avenue. He died on December 12, 1938, leaving behind his wife, Anna. He is interred in St. Mary's Cemetery in Clark.

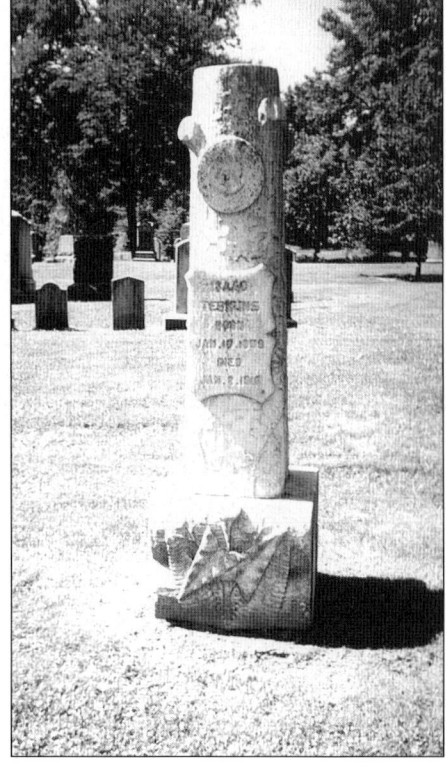

ISAAC N. TERHUNE. Isaac N. Terhune (January 19, 1856–January 2, 1913) was the 15th, 17th, and 20th mayor of Clark. A Democrat, he served in 1895, from 1900 to 1901, and from 1911 to 1912. He was a farmer and a state and county forestry ranger. Upon his death, friends cemented a tree from his farm to be used as his tombstone in Hazelwood Cemetery.

BENJAMIN KING. Benjamin King (1856–February 12, 1929) was the 16th and 22nd mayor of Clark. A Republican, he served from 1896 to 1899 and 1914 to 1923. He was the foreman of the Essex felt mills, formerly Bloodgood's, and was one of the architects who transformed Clark into a small town. He is interred with his wife, Dora L. Schumacher King, in Hazelwood Cemetery.

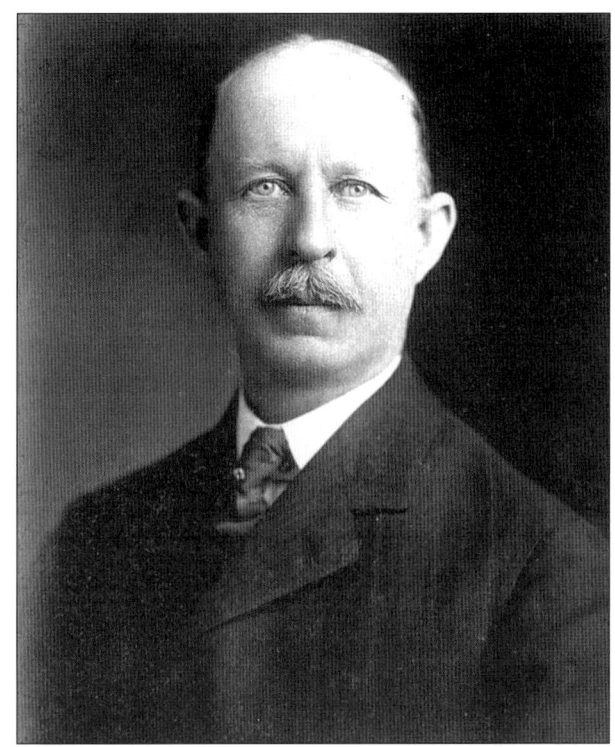

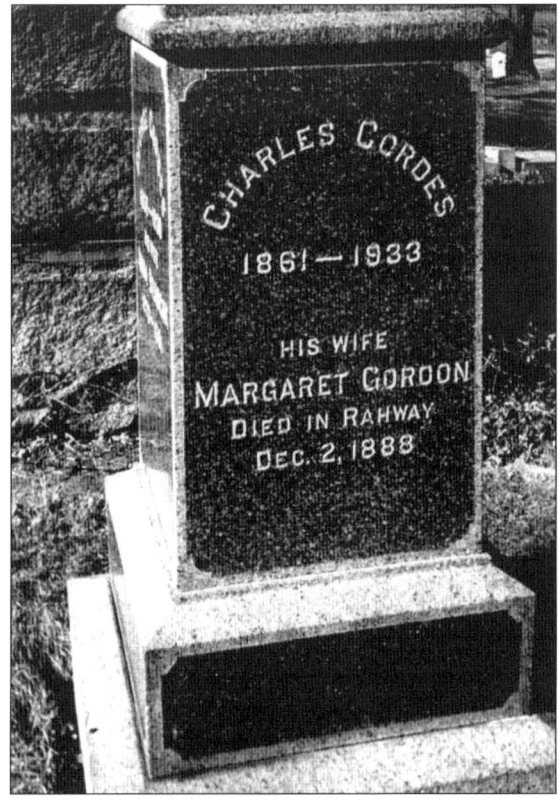

CHARLES CORDES. Charles Cordes (August 27, 1862–August 26, 1933) was the 18th mayor of Clark. He served in 1902 and was a Democrat. Following in his brother's footsteps, he became the mayor of Clark in 1902. After only one year, he also retired back to farm life. He died on August 26, 1933, and is buried in his family's plot in St. Mary's Cemetery in Clark.

GEORGE H. HOLLAND. George H. Holland (October 10, 1878–August 18, 1969) was the 21st mayor of Clark. He served in 1913 and was a Democrat. During his one year as mayor, he also served on the Union County Board of Chosen Freeholders from 1919 to 1933 and brought great assistance to Clark. Retiring from politics in 1934, he moved to Elizabeth with his wife, Helen Haggerty Holland. He died on August 18, 1969, and is interred in Rahway Cemetery.

THEODORE M. LANG SR. Theodore M. Lang Sr. (November 8, 1877–September 25, 1942) was the 23rd mayor of Clark. He served from 1924 to 1927. He was a Democrat. Born in Germany, Lang settled in New York State. He moved to Clark in 1915 and worked as a construction foreman. His wife, Rose Maithoff Lang, died on August 2, 1927. He died of a heart attack on September 25, 1942, and was laid to rest in Cloverleaf Memorial Park in Woodbridge.

HERMAN A. GRAVES. Herman A. Graves (1890–December 21, 1947) was the 24th mayor of Clark. A Republican, he served from 1928 to 1930. A printer for the *Elizabeth Daily Journal,* he lived on Valley Road with his wife, Alice Kaufman Graves. He was the only mayor to have an attempt on his life made. He lost his only son, Melvin, in World War II. Graves died of a heart attack, and his remains were cremated.

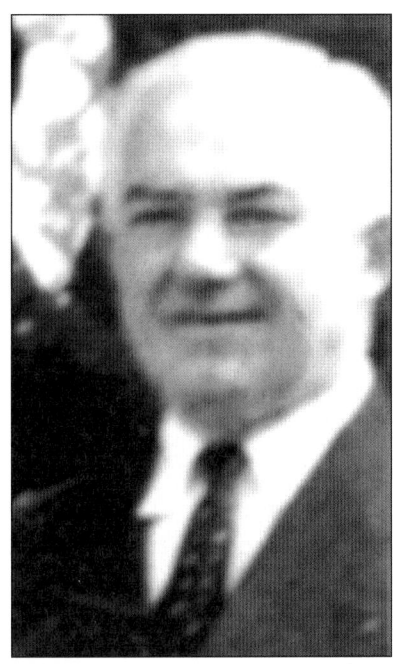

CLARENCE D. KNIGHT. Clarence D. Knight (1878–June 14, 1945) was the 25th mayor of Clark. He served in 1931 and was a Republican. A resident of Harrison Street, he worked as a pattern maker for Eastern Aircraft Corporation. He was born in New York and moved to Clark in 1920. He died on June 14, 1945, leaving behind his wife, Helena B. Knight. They are interred in Rahway Cemetery.

WELLS E. MYRICK. Wells E. Myrick was the 26th mayor of Clark. He served from 1932 to 1933. He was a Democrat and an Independent. He lived at the intersection of Raritan Road and Westfield Avenue, and he is the mayor who is least known about. He disappeared from public life in 1934, and then moved away from Clark. Shown is Mayor Myrick's home.

CHARLES F. SCHULTZ. Charles F. Schultz (1890–July 1, 1961) was the 27th and 29th mayor of Clark. He served in 1934 and in 1938. He was a Democrat and a Republican. Born in Iselin, Schultz lived at 12 Bartell Place in Clark. He was a painter and home repair contractor. He died on July 1, 1961, and is buried with his wife, Elise C. Schultz, in St. Mary's Cemetery in Rahway.

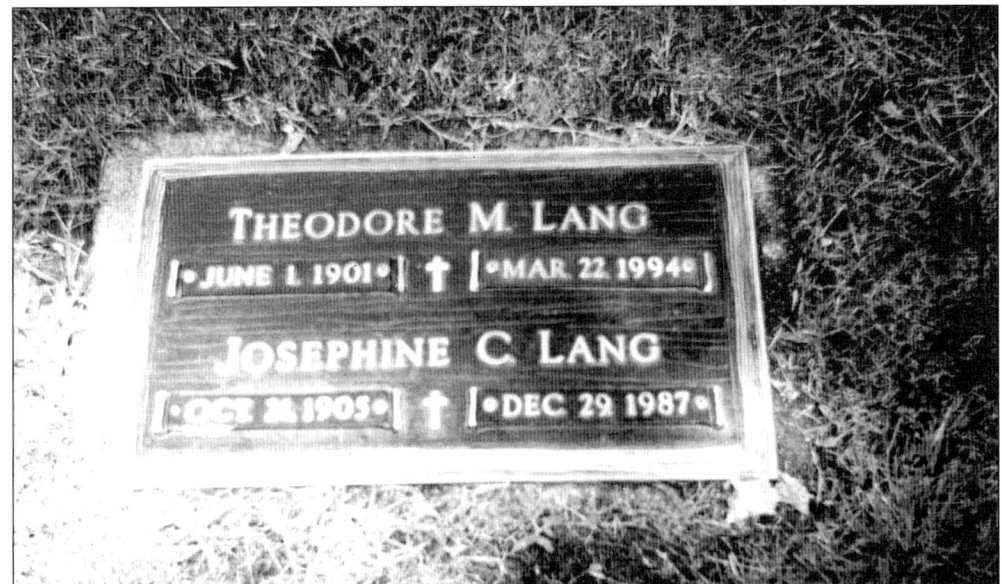

THEODORE M. LANG JR. Theodore M. Lang Jr. (June 1, 1901–March 22, 1994) was the 28th and 31st mayor of Clark. A Democrat, he served from 1935 to 1937 and from January 1, 1941 to July 1, 1941. He and his father were the only father and son to serve as mayors. He was the only mayor to be removed from office by public referendum, thereby changing the form of government from town committee to town commission.

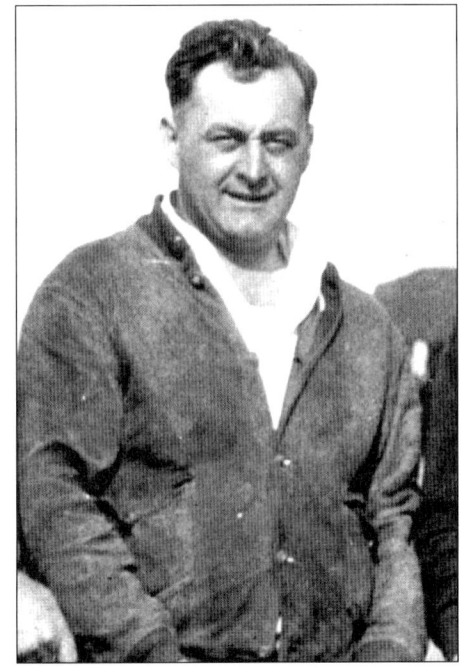

ROBERT HODGE. Robert Hodge was the 30th mayor of Clark. He served in 1939 and 1940. He was a Republican. Hodge lived in Clark at the corners of Westfield Avenue and Raritan Road. After serving only two years, he moved away from Clark to Greenbrook Township.

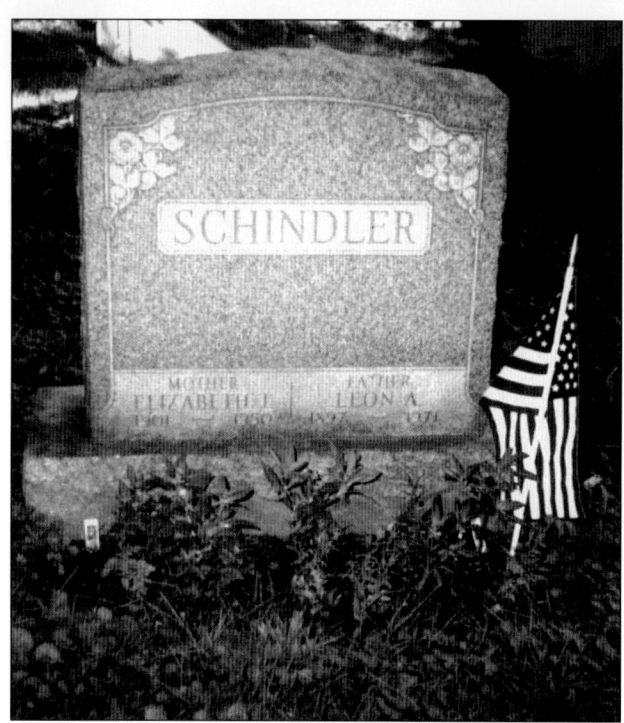

LEON A. SCHINDLER. Leon Schindler (1879–June 8, 1971) was the 32nd mayor of Clark. A Republican, he served from July 1, 1941, to May 19, 1953. He was the first mayor under the commission form of government and one of the most prolific leaders in Clark's history. He helped lead the township through the construction of the Garden State Parkway. Schindler Road was named in his honor. He is interred in Rahway Cemetery.

JAY ANDREW STEMMER. Jay Andrew Stemmer (October 29, 1915–present) was the 33rd mayor of Clark. A Republican, he served from May 19, 1953, to July 31, 1959. Originally the township clerk, he rose to become mayor. Stemmer Drive is named in his honor. Mayor Stemmer resigned as mayor on July 31, 1959, to become a Union County freeholder. He retired from politics and lives in North Carolina.

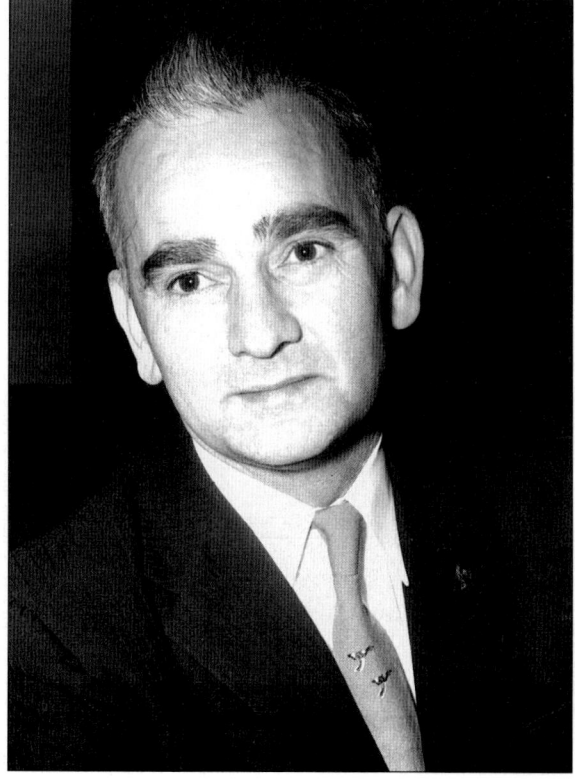

JOHN J. O'CONNOR. John J. O'Connor (1918–c. 1990) was the 34th mayor of Clark. A Republican, he served from July 31, 1959, to December 31, 1960. With the resignation of Jay Stemmer as mayor, John J. O'Connor, Clark's commissioner, ascended to the position of mayor on July 31, 1959. Mayor O'Connor chose not to seek a full term and retired from politics. He lived at 4 Maple Street, then moved to Florida. He passed away in the early 1990s.

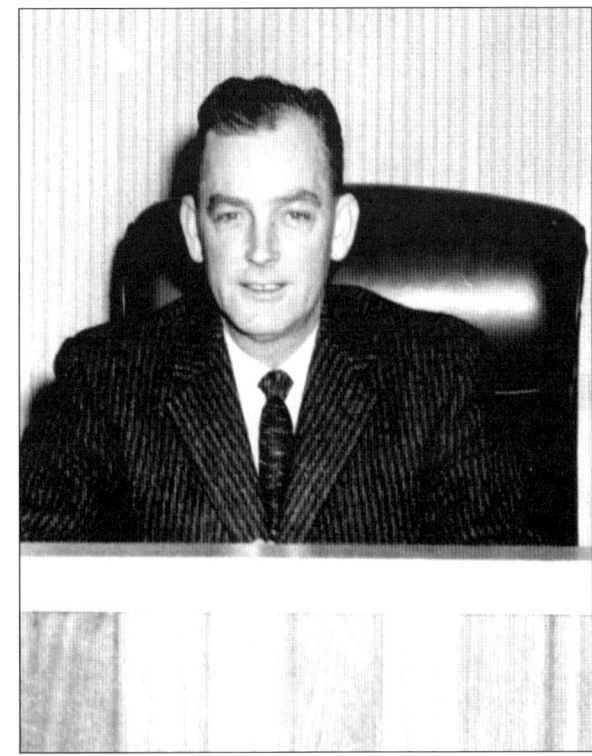

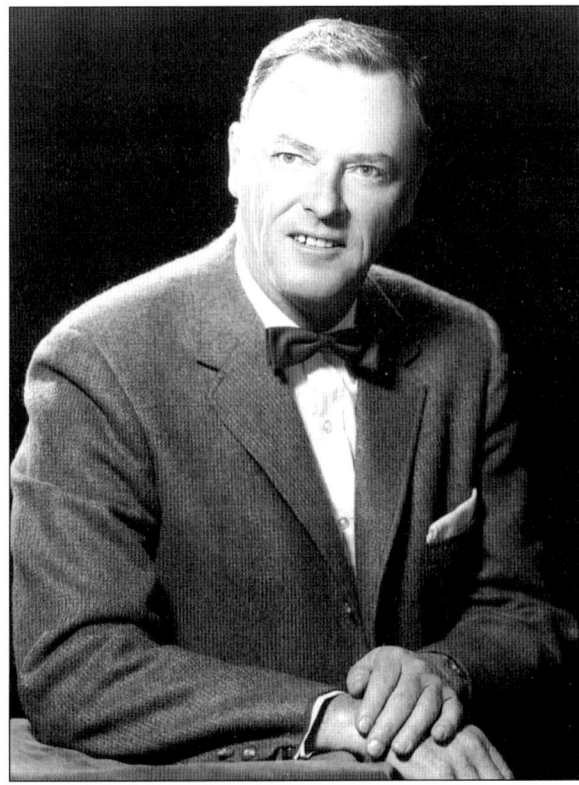

WILLIAM J. MAGUIRE. William J. Maguire (June 12, 1916–November 5, 1997) was the 35th mayor of Clark. A Republican, he served two terms, from January 1, 1961, to December 31, 1968. He later went on to become a Union County freeholder and the only person from Clark to be elected to the state legislature as a member of the general assembly from the 22nd District in 1973. He served in that capacity until 1982. He died on November 5, 1997.

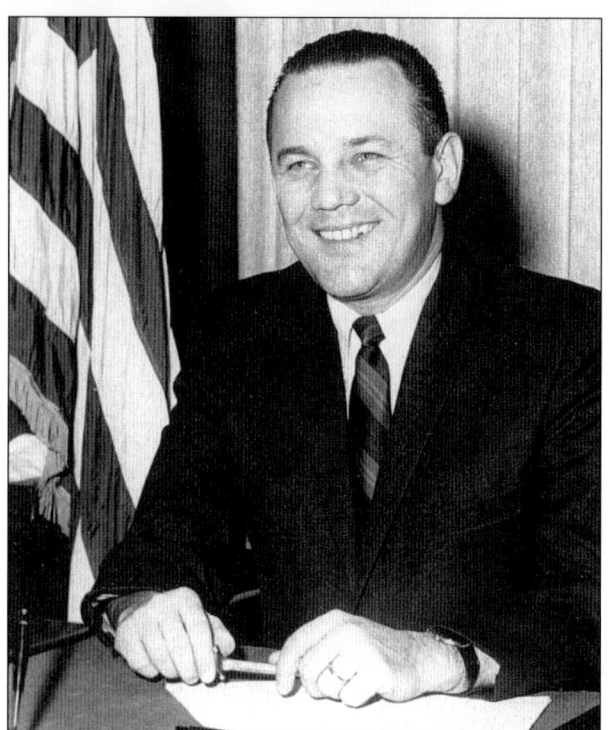

THOMAS A. KACZMAREK. Thomas A. Kaczmarek (August 10, 1928–present) was the 36th mayor of Clark. A Democrat, he served from January 1, 1969, to December 31, 1972. In only one term, Kaczmarek is credited with saving the Oak Ridge Golf Course from being developed into an industrial park. He was elected to the Union County freeholder board in 1971. He retired as president of the Kaczmarek Circus Shoe Store in Elizabeth and is currently a U.S. Olympic Association boxing referee.

BERNARD G. YARUSAVAGE. Bernard G. Yarusavage (February 27, 1924–present) was the 37th and 39th mayor of Clark. A Republican, he served from January 1, 1973, to December 31, 1984, and from January 1, 1989, to December 31, 1992. First elected mayor in November 1972, he was reelected in 1976 and again in 1980. Defeated in the 1984 election, he was returned to office in January 1989 and defeated in 1992. He retired from public life in 1998.

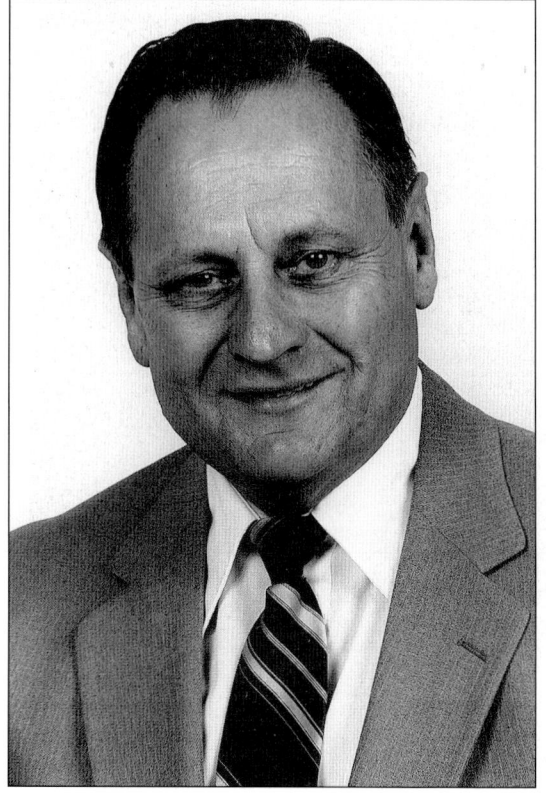

GEORGE G. NUCERA. George G. Nucera (August 30, 1930–present) was the 39th mayor of Clark. He served from January 1, 1985, to December 31, 1988. He is a Democrat. In only one term, he initiated the township's takeover of the Charles H. Brewer School and converted it into the town hall, senior center, and recreation center. He worked on revitalizing Clark's youth programs and fostering community pride. He was defeated for reelection in 1988.

ROBERT SAUL ELLENPORT. Robert Saul Ellenport (July 25, 1949–present) was the 40th mayor of Clark. A Democrat, he served from January 1, 1993, to December 31, 2000. Elected as the non-cogeneration plant candidate in the 1992 election, he established the Clark Wildlife Habitat. Reelected in 1996, he retired from politics in 2000 and resides in Clark with his wife, Beverly.

SALVATORE F. BONACCORSO. Salvatore F. Bonaccorso (December 20, 1960–present) is the 41st mayor of Clark. A Republican, he began his term on January 1, 2001. The first of the baby-boomer generation and a hometown boy, he grew up to become Clark's mayor. A 1978 Arthur L. Johnson Regional High School graduate, he is the president of Bonaccorso Landscaping, a third-generation, family-owned business. Mayor Bonaccorso has been an advocate of cleaning up Clark's image and revitalizing the senior center and recreation department. He established the township's first senior citizen fitness center in 2003 and has been instrumental in many progressive programs as Clark enters the 21st century. He resides in Clark with his wife, Geraldine, and his two daughters.

Members of the Town Council
January 1, 1961–January 1, 2004

Name	Years Served	Ward Party
Albanese, Angel	2001–present	L R
Anderson, Jean F.	1981–1982	2 R
Apelian, Virginia	1976, 1979–1982	L/1 R
Barr, Alvin	2001–present	L R
Barr, Jon-Henry	1993–1994	1 R
Bodnar, John, Jr.	1971–1979	1,4 D
Bodnar, John, III	1983–1984	R
Bonaccorso, Salvatore F.	1997–2000	L R
Bothe, Robert J.	2003–present	3 R
Boyle, John F.	1967–1968	3 D
Burger, Richard C.	1967–1974	2 D
Camacho, Rodger L.	1990–1992	L R
Campana, Peter M., Sr.	1980–1982	4 D
Caruso, William D.	1985–1994	2 D
Catalano, Victor J.	1965–1968	L D
Cislo, Michele	1999	2 D
Connor, John H.	1961	3 D
Cordone, Victor E.	1961–1964	L D
Cristiani, Carmine F.	1987–1994	4 R
Crook, Warren C.	1961–1962	1 R
Cullen, John J.	1975–1978	1 D
DeLuca, Ruth Ann	1983–1986, 1989–1990	3/L R
Dios, Manuel S.	1973–1980	L R
Drozdowski, Leo J.	1993	1 D
Eckel, Fred C.	1981–1988	L R/D
Ellenport, Robert S.	1987–1992	1 D
Farmar, John J.	1961	4 D
Farrell, Joseph F., Jr.	1977–1980	L D
Ferrara, Marty	1999–2002	4 D
Getchis, Edward P.	1963–1970	4 R
Haggerty, John F.	1961–1962	2 R
Harris, Harold E.	1961–1964	L D
Hatch, Lyle R.	1995–1998	2 R
Hayden, Bernard R.	1975–1981, 1985–1992	2/L D/R
Heijselbak, Siggo V.	1962–1966	4 D
Hill, Henry A.	1966	4 D
Hudak, LizBeth A.	1995–1998	4 R
Johnson, Robert M.	1963–1966	2 R
Kaczmarek, Thomas A.	1967–1968	4 D
Kaznowski, Richard P.	1993–1994, 1999–2002	3 D
Krov, Raymond B.	1983–1986	1 D

Name	Years Served	Ward Party
Kuchar, William	1996–2000	L D
Kumpf, Almamae D.	1973–1976	L R
Labella, Donald W.	1973–1982	3 D
Labella, Rocco J.	1991–1993	3 D
LeWand, Stanley F.	1969–1972	L D
Mazzarella, Frank G.	1996–1997, 2003–present	1 D/R
Memmer, Dolores	1999–2002	1 R
Neary, Roy F.	1969	3 D
Nevargic, Peter P.	1999–present	2 R
Nowakoski, Stanley F.	1969	3 D
Nozza, Gregory M.	1999	2 D
Nucera, George G.	1981, 1983–1984	2 D
Paschenko, Alexandra	1965–1968	L D
Pisansky, John A.	1969–1972	L D
Pluta, Carol A.	1987–1990	3 R
Pozniak, Joseph B.	1973–1988	L R/D
Roman, Robert A.	1969–1974	4 D
Rotondo, Gary	1995–1996	1 D
Ruggiero, Salvatore	1993–1996	L D
Rybak, Joseph	1989–1992	L R
Sangiulliano, George A.	1981–1984	L R
Sherman, Harold R.	1962	2 D
Skobo, James, B.	1993–1996	L D
Soyka, Marie T.	1993–2000	L D
Spies, Ernest M.	1997–1998	1 R
Taylor, Robert G.	1973	3 R
Toal, Brian P.	1985–1986, 2003–present	4 R
Ulrich, James F.	2001–present	L R
Wallano, Angelo Charles	1969–1972	L D
Winters, Thomas P.	1963–1966	3 D
Xifo, Enrico Harry	1961–1964	L D
Yarusavage, Bernard G.	1965–1968	L R
Yarusavage, Bernard G.	1969–1972, 1995–1998	3 R

MEMBERS OF THE TOWNSHIP COMMITTEE
APRIL 11, 1864–JULY 1, 1941

Name	Years Served
Andren, Carl	1924, 1926
Atteridge, Stockton H.	1871–1872
Bender, Henry	1906–1907
Bloodgood, William E.	1864, 1865
Bowne, Hugh H.	1873–1875, 1877–1881
Brewer, Charles H.	1916–1919
Brown, Adam	1872
Clark, William	1876–1877
Compton, Alvan	1885–1887
Cordes, Charles	1900–1903
Cordes, George	1892–1894
Dougherty, William H.	1865–1866
Dunn, Leonard	1864–1867, 1870–1872
Enders, William H.	1873–1875, 1877, 1884–1889
Fitzpatrick, Thomas	1915–1916
Garthwaite, Matthias F.	1874–1876
Gibson, Andrew	1890–1892
Haliday, John A.	1889–1891
Hartshorne, George	1882–1884
Hodge, Robert	1938–1940
Holland, George	1912–1914
Kaufman, Sidney C.	1/1/1941–7/1/1941
Keller, Peter	1/1/1941–7/1/1941
King, Benjamin	1895–1899, 1903–1906, 1908–1910, 1914–1923
Knight, Clarence D.	1929–1931
Knoll, George	1932–1934
Lambert, Albert	1894–1996
Lang, Theodore, Jr.	1934–7/1/1941
Lang, Theodore, Sr.	1923–1928
Leichtnam, Jacob	1918–1927
Loeser, George	1935–1937
Mays, Edmund	1904–1906
Myrick, William J.	1931–1933
Reifel, Marx	1869, 1888–1893
Ritter, August	1870
Russell, Robert A.	1864–1865, 1867, 1870–1872
Schieferstein, Henry	1911–1913

Name	Years Served
Schieve, Henry	1920–1922
Schindler, Leon A.	1/1/1941–7/1/1941
Schultz, Charles	1933–1940
Schumacher, Fredreck	1877
Scudder, Linus M.	1880–1881
Smith, Lewis	1882–1885
Smith, William	1900–1902
Stevens, Clark	1869
Terhune, Andrew	1873
Terhune, Isaac	1893–1895, 1897–1901
Thompson, Thomas	1928–1930
Thompson, William J.	1874–1876, 1879, 1887, 1902–1911
Vail, Eden	1878–1879
Vail, Israel	1869
Ward, John W.	1886–11/3/1887
Weimar, John	1864–1868
Westervelt, James B.	1868–1869
Whitney, John F.	1864

MEMBERS OF THE TOWNSHIP COMMISSION
JULY 1, 1941–JANUARY 1, 1961

Name	Years Served
Evans, Thomas R.	7/1/1941–5/17/1949
Hawkins, Paul F.	5/19/1953–5/7/1955
Hill, Henry A.	5/17/1949–4/2/1952
Laine, Frank I.	5/19/1953–3/1/1956
Lilley, Walter F.	5/7/1955–12/31/1960
Maguire, William J.	7/31/1959–12/31/1960
O'Connor, John J.	3/1/1956–12/31/1960
Resch, Oliver B.	4/2/1952–5/19/1953
Schindler, Leon A.	7/1/1941–5/10/1953
Stemmer, Jay Andrew	4/2/1952–7/31/1959
Wilson, Warren C.	7/1/1941–4/2/1952

Three
THE POLICE

THE CLARK POLICE DEPARTMENT, 1938. Standing in front of the Ginesi family garage on Raritan Road, where the patrol car was kept, from left to right, are: Paul Meissner (police director), Peter Peterson, Christopher Meyers, Joseph Ginesi, William White, Ernest Enquist, and William Muth (police chief).

THE CLARK POLICE DEPARTMENT, 1946. Mayor Leon Schindler of Clark conducts an inspection of the department's new patrol unit in 1946. From left to right are an unidentified patrolman, Charles Fullager, Mayor Schindler, Joseph Catalano (police director), Christopher Meyers, Chief Muth, and an unidentified patrolman.

THE CLARK POLICE DEPARTMENT COLOR GUARD, 1975. Seen here are, from left to right, the following: (front row) Lt. Al Yersevich, Det. Michael Kuch, Chief Anton Danco, Capt. William Duffy, and Sgt. Fred Carrick; (back row) Robert Hartong Jr., Guy Everest, Richard Clair, William Zdarko, and Sgt. Robert Clark.

THE CLARK POLICE DEPARTMENT, 1958. This 1958 photograph shows the police color guard unit on Westfield Avenue.

CLARK'S POLICE HEADQUARTERS. This small building was located between Liberty and Joseph Streets on Broadway. It was used as Clark's police headquarters and civil defense headquarters during the 1930s and 1940s. It was razed in 1985 to make way for townhouse construction.

INSIDE HEADQUARTERS. This 1946 photograph shows the interior of Clark's police headquarters.

CLARK POLICE ON PARADE. Members of the department are seen marching down Westfield Avenue in the Memorial Day parade of 1958.

CLARK'S FINEST, 1952. Pictured here are, from left to right, Capt. John Waterson, Anthony Smar, Robert Hartong, Andy Chabak, Al Muskin, Madeline Faede, and Chief William Muth.

THE CLARK POLICE DEPARTMENT, 1958. As the township expanded, so did the need for a stronger and more modern police department.

A Rescue Vehicle. The Clark Police Department enters the modern age with the department's acquisition of a new emergency rescue vehicle in 1960.

Crossing Guards. In 1962, the Clark Police Department established the first local school crossing guard unit.

A New Patrol Car. Police officials accept a new patrol unit in 1969.

A Department Portrait. Members of the Clark Police Department pose for a photograph in 1949.

WILLIAM MUTH AND ANTHONY P. SMAR. Chief William Muth (left) served from 1952 to 1969. Chief Anthony P. Smar (right) served from 1969 to 1989.

ONE CHIEF. Pictured here is Chief Anton W. "Sandy" Danco Jr., chief since 1989.

Four
July 4, 1971

William J. Waterson (1946–1971). William J. Waterson, a Clark police officer, was born on September 13, 1946. He was killed in the line of duty on July 4, 1971.

THE LINE. Patrolmen line up along Madison Hill Road for William J. Waterson's funeral on July 7, 1971.

The Staging Area. Seen here is the staging area at Waterson's funeral on July 7, 1971.

The Setup. Seen is the setup for Waterson's funeral on July 7, 1971.

PATROLMAN WATERSON'S FUNERAL. Mourners enter the Walter Johnson funeral home on Raritan Road.

THE PROCESSION. Patrolman Waterson's funeral procession is seen here.

TRAGIC EVENTS. Shown here is the scene of the tragic events of July 4, 1971. The Howard Johnson Motor Lodge was located on Central Avenue, presently the site of Shop Rite.

THE GRAVE. Patrolman Waterson's grave is located in Fairview Cemetery in Westfield.

The Memorial. Patrolman William J. Waterson's memorial is located in front of police headquarters on Westfield Avenue.

Five
THE CLARK VOLUNTEER EMERGENCY SQUAD

THE CLARK VOLUNTEER EMERGENCY SQUAD. Upon organizing into a first-aid squad, the members of the Clark Volunteer Emergency Squad needed an ambulance. After conducting a brief search, they acquired Garwood's used 1932 Meteor Continental and launched it into service on March 8, 1942.

THE VOLUNTEER EMERGENCY SQUAD. Squad members pose for their official photograph in 1952 at headquarters, which was then located at 10 Brant Avenue.

SAVING LIVES. Members of the Clark Volunteer Emergency Squad were called to the scene of a traffic accident on Raritan Road on January 6, 1953. Shown squad members Maytner, Jarvis, and Carbone.

THE CLARK RESCUE SQUAD, 1942. Members of the rescue squad stand ready for the call.

FIRST-AID TRAINING. First-aid squad members conduct a public first-aid class in May 1953. Shown are H. Horn, J. Cittadino, D. Horn, H. Jarvis, E. Carroll, and J. Smith.

A NEW AMBULANCE. With the construction of the Garden State Parkway underway, the township received a new ambulance from the state to help deal with the pending needs of the soon to be opened parkway.

POINTING TO A BRIGHT FUTURE. In this 1967 photograph, first-aid squad members survey the plans and site of their new squad house, which would be located on Raritan Road.

THE 1956 AMBULANCE. The emergency squad upgraded its ambulance, as seen in this photograph of the new 1956 Cadillac Superior.

CAN YOU HEAR US? With the space age in full swing, the emergency squad received state-of-the-art radio equipment from the RCA Corporation. The two-way radios were installed in the new 1961 Cadillac Superior ambulance.

THE HEADQUARTERS. Shown here are the members of the squad in front of the volunteer emergency squad headquarters on Raritan Road in 1968.

SQUAD MEMBERS, 1964. Members of this squad were Harry Jarvis, Sue King, Emma King, Harry Paulmenn, Fred Reick, Ed Carroll, Joe Good, C. Brown, Bill McClymont, Bill Hoeffler, Bob Curry, R. Wilson, Paul Miklas, T. Minarchenko, Henry Klett, A. Jesienski, J. Kelly, J. Kosik, and V. Bertlson.

IN SERVICE. In preparation for a call, the Clark Volunteer Emergency Squad is seen filling up its 1961 ambulance at Tudor's Chevron gas station, located at the corner of Madison Hill and Raritan Road, at a time when gas was 29¢ per gallon.

READY TO SERVE. Members of the emergency squad stand ready in this 1970 photograph, taken outside of headquarters on Raritan Road.

THE LADIES AUXILIARY. This is what many would call the backbone of the emergency squad. The members of the Ladies Auxiliary are pictured here in 1968.

A FLAG RAISING. The Stars and Stripes is raised at the official dedication of the new squad house at 875 Raritan Road on October 13, 1968.

SOUND THE SIREN! Clark children receive a hands-on demonstration of a Clark ambulance at the new squad house dedication on October 13, 1968.

THE SPIRIT OF '76. In 1976, as the nation celebrated its bicentennial, the Clark Volunteer Emergency Squad changed its uniforms from the ice-cream-man look of the 1950s to a more athletic, sports-minded, baseball-uniform look.

THE CLARK VOLUNTEER EMERGENCY SQUAD, 1986. Shown are members of the Clark Volunteer Emergency Squad of 1986.

THE CLARK VOLUNTEER EMERGENCY SQUAD, 1998. Members are seen showing off their new red jump suits alongside the new cadet corps. This is a branch of the squad that recruits high school students who are going to attend college and major in the medical profession. This concept was established by squad president Laurie Flood Sheldon in 1998.

Six
The Clark Volunteer Fire Department

The Seal. Seen here is the fire department's seal.

THE CLARK FIRE COMPANY NO. 1, AUGUST 1954. On the grounds of Russell Yarnell's Ye Olde Log Cabin on Raritan Road, the members of the Clark Volunteer Fire Department joined together for their 30th anniversary picnic.

CLARK'S SECOND FIRE TRUCK. A 1929 American LaFrance pumped 600 gallons of water per minute. It was acquired through the efforts of Clifford Humiston (fire chief), Herman Graves (mayor), Thomas Thompson and Clarence Knight (township committee members), and Samuel Flamm (township clerk).

THE 1929 AMERICAN LAFRANCE. The pumper is shown in front of the Holland barn, which also served as the firehouse. It was located at the present-day entrance to the Garden State Parkway North at Exit 135.

THE CLARK VOLUNTEER FIRE COMPANY, 1930. Poised for action at a moment's notice are the members of the Clark Volunteer Fire Department, as seen in this New Year's Day photograph. It was taken at their new fire station, which was built across the street from the Holland barn on Central Avenue.

THE CLARK VOLUNTEER FIRE DEPARTMENT, 1954. Members are gathered in front of fire headquarters on Westfield Avenue during their 30th anniversary celebration.

AT THE WESTFIELD AVENUE FIREHOUSE. Fire Chief Tony Malanga (center) and his officers pose for a photograph in front of the Westfield Avenue firehouse in 1964.

THE CLARK VOLUNTEER FIRE DEPARTMENT, 1964. The entire department was photographed in 1964 for the township's centennial year. This photograph was taken in front of the municipal building. Mayor Bill Maguire and Charles Grunder, the public safety director, are shown in the center with Chief Malanga.

THE CLARK FIRE DEPARTMENT, 1964. In 1964, Clark residents could see any one of these fire trucks called into action at any time of the day or night.

THE CLARK FIRE DEPARTMENT, 1958. Fire fighters were called into action in March 1958 at the intersection of Valley and Emerson Roads, the site of Clark's historic Helca gun powder mill row houses of the 1880s. The mill had been transformed into housing during the 1920s. Half of the row houses were destroyed in this fire.

A TRAVELING CIRCUS. During the spring of each year in the 1940s, 1950s, and 1960s, a traveling circus or carnival would pass through Clark. In this 1964 photograph, a promotional circus truck caught fire and gave the residents of Clark a spectacular free show.

THE NATIONAL CHAIR FIRE, 1963. Shown here is the township's first ever four-alarm fire, which occurred in 1963. During the 1950s, the Taylor & Bloodgood felt mill had been transformed into the National Chair Company, which manufactured household furniture. With the building full of wood, furniture, paint, and lacquer, an inferno was created that was the largest fire in the history of the department.

THE CLARKTON SHOPPING CENTER. On August 13, 1981, the south section of the Clarkton Shopping Center was destroyed by a fast moving fire.

THE BROADWAY FIREHOUSE. The new firehouse was dedicated on June 14, 1969. Mayor Thomas Kaczmarek officiated with other Clark dignitaries, including Robert Volpe (fire chief), Thomas P. Kelmartin (public safety director), Fr. Dennis Whelan of St. Agnes Church (fire department chaplain), and John Pisansky (council president).

AT THE BROADWAY FIREHOUSE, 1982. Shown at the Broadway firehouse are the 1976 fire department aerial truck and the new 1982 Mack pumper.

THE CLARK FIRE SUBSTATION NO. 2. In an effort to provide a quicker response time, the Clark Volunteer Fire Department constructed a substation on Raritan Road. Located next to the emergency squad headquarters, it was dedicated in 1989. It was built in an effort to provide better coverage for the south end of the township.

DECEMBER 31, 1989. On New Year's Eve 1989, an Exxon gasoline tanker making a delivery from its plant in Linden to a customer in Edison lost control on black ice. The tanker jackknifed and overturned at the intersection of Madison Hill and Raritan Roads. The driver was pinned in the wreck as gasoline leaked around him. Through the valiant efforts of the Clark fire and rescue squads and the police department, the driver was saved and a disaster in the township was averted.

THE EXXON GAS STATION. On May 27, 1992, the Exxon gas station, located at 226 Westfield Avenue, was completely destroyed by a gasoline fire. This photograph was taken by Tim George.

THE OATES HOUSE FIRE, 1995. On the evening of December 17, 1995, the residents of 51 Amelia Drive were awakened to find their house on fire. They escaped with only the clothes on their backs. The cause was later determined to be a broken gas line.

VOLUNTEERS. Members of the Clark Volunteer Fire Department pose for a photograph in 1987.

THE CLARK FIRE DEPARTMENT, 2001. Members of the Clark Volunteer Fire Department pose for the department's official photograph with Richard Brattole (fire chief), in the center of the first row; Sal Bonaccorso (mayor), on the left in the first row; and Alvin Barr (councilman-at-large and liaison), on the right in the first row.

CHIEFS OF THE CLARK VOLUNTEER FIRE DEPARTMENT
1924–2003.

1924–1925 Herbert Fredericks
1926 William Leichtnam
1927 George Holland Jr.
1928 Edward Grube
1929 Clifford Humiston
1930 Paul Leichtnam
1931 Harry Tuthill
1932 George Walker
1933 Robert Walker
1934 Joseph Holland
1935 Emil Meissner
1936 Ernest Keller
1937 John Hill
1938 Herman Meissner
1939 Joseph Leichtnam Sr.
1940 Charles Meickle
1941 John Ruddy
1942 Peter Peterson
1943 Michael Gudor
1944 Max Junker
1945 Joseph Leichtnam Sr.
1946 Walter Pachucki
1947 Robert Funk
1948 Wilford Stacy
1949–1950 Stephen Graczyk
1951 James Tuthill
1952 Harry Palmquist
1953 Robert Wills
1954 Martin Haluza
1955 Alex Botulinski
1956 Peter Witkowski

1957 Alfred Kumpf
1958 John Flachek
1959 Rudolph Tomasovic
1960 Thomas Schindler
1961 Frank Bihon
1962 Robert Jeney
1963 Allen Palmquist
1964 Anthony Malanga
1965 William Miskovich
1966 Raymond Blakley
1967 Robert Wagner
1968–1969 Robert Volpe
1970–1971 Robert Siessel
1972–1973 Frank Oberlies
1974 Vincent Denchy
1974–1975 Francis P. Brattole Sr.
1976–1977 John Reider
1978–1979 Thomas Hyslop
1980–1981 Arthur Slinger
1982–1983 Vincent S. Pereira
1984–1985 Howard Payne
1986–1987 Donald Kellerman
1988–1989 Jerry Fewkes*
1990–1991 Frank P. Brattole Jr.*
1992–1993 Chris Buccarelli*
1994–1995 Frank Cerasa*
1996–1997 Daniel Sheldon*
1998–1999 Matthew Hampp*
2000–2001 Richard Brattole*
2002–2003 Andrew Beach*
2004–present John Pingor*

* active member

Seven
School Days

A Celebration. Children of Clark celebrate July 4, 1886.

THE SCUDDER SCHOOLHOUSE. Located at the corner of present-day Raritan Road and Central Avenue, the Scudder Schoolhouse served Clark school children from the first to eighth grades. Pictured is the class of 1864.

THE LOCUST GROVE SCHOOLHOUSE. Clark's second schoolhouse, the Locust Grove Schoolhouse, was constructed in the 1840s on Quaker Road, presently Lake Avenue. It was built by the Bowne family of Oak Ridge to educate the local children in the southern end of Clark Township. The building served as a public school on weekdays, a Sunday school, and a community meetinghouse on weekends. It closed as an operating school in 1922, and the building remained until January 1941, when it was destroyed by fire. It was located on Lake Avenue on the current site of Rob's Service Station.

THE ABRAHAM CLARK SCHOOL. When Clark Township separated from Rahway in 1864, residents inherited the one-room Scudder Schoolhouse. In the years following, it was always the desire of the citizens to build a larger, more modern school to meet their growing needs. In 1913, the dream was fulfilled with the construction of the four-room Abraham Clark School.

THE CHARLES H. BREWER SCHOOL. This was the first of the postwar school expansions. With the baby boom in full swing and the Garden State Parkway set to open in the 1950s, the need for additional schools became apparent. Named in honor of longtime Clark Board of Education president Charles Henry Brewer, the building was dedicated in 1949.

CHILDREN OF THE PAST. Abraham Clark School first and second graders are captured in this November 6, 1916, photograph. (Courtesy of the Bartell Family collection.)

A BRIGHT FUTURE AWAITS. In this photograph, taken in June 1919, are Abraham Clark School students.

THE CLASS OF 1922. Students in the sixth-grade class pose for a photograph in March 1922.

STUDENTS OF CLARK. Students of Abraham Clark School pose in 1924.

THE EIGHTH-GRADE CLASS OF 1937. Members of the Class of 1937 prepare for their graduation day under the supervision of principal Frank Hehnly and teachers Miss Wolfe and Miss McDonald.

THE CLASS OF 1941. On their eighth-grade trip, members of the Abraham Clark School Class of 1941 pose for a group photograph. This photograph was taken at the new Rahway River Park.

84

THE CLASS OF 1950. The Class of 1950 was the first graduating class of the Charles H. Brewer School in June of that year. The graduation ceremony was conducted at the Rahway High School, since construction of the Brewer School auditorium was incomplete at the time.

THE CLASS OF 1955. Clark eighth-grade students stand for their graduation photograph in the Brewer School auditorium.

THE MAYPOLE, 1952. An annual tradition and passage of spring, the Maypole dance was conducted each year at the Abraham Clark School.

THE SCHOOL BAND. The Arthur L. Johnson Regional High School Band and Color Guard perform at Mount Vernon, the home of George Washington. They participated in a national band competition there in 1982.

Eight
OUR TOWN

AN AMERICAN DAY PARADE. The spirit of America is shown in this May 16, 1943, parade photograph.

DILL'S TAVERN. This landmark, operated by Henry Dill in the mid-1920s, became a haven for weary farmers needing a night on the town. Made famous by the Dill's Tavern Zoo, which delighted area children with its pet monkey and dancing bear, the tavern was a place for the entire family. Dill arranged a tearoom for the ladies, a zoo for the children, and the bar for the men. It was turned into the Clark Rest in 1957. Located on the corner of Central Avenue and Raritan Road, it was closed in 1967 and razed in 1970.

CHARLIE KELLY'S. Seen here is a Clark landmark that entertained area residents from 1940 to August 1985, when it closed its doors.

THE SCHUMACHER ESTATE. This landmark estate was the home of Clark resident Frederick Schumacher and his wife, Anna Schumacher. During the 1870s and 1880s, this was known as the social center of Clark for its many fine parties and dances of the day. Today, it is the site of Bartell Park on Bartell Place. This photograph was taken in 1877.

MA GERTS. In 1899, Anna Schumacher died, and only months later, Frederick Schumacher passed away. The Schumacher estate was sold to a woman from New York City named Freida Gertrude Cammeron, who wanted to open a fine hotel and lodge for tourists visiting Rahway. She operated the Cammeron Hotel as a respectable establishment until the 1920s, when it was transformed into the famous Ma Gerts, a bordello and speakeasy.

THE TROLLEY. Clark's own trolley, on the Westfield & Elizabeth Street Railway Company line, extended from Elizabeth to Westfield and traveled down Central Avenue using the rail line that is presently behind Shop Rite. The trolley line continued onto present-day Walnut Avenue and proceeded up Broadway. It continued into Rahway and down to Boynton Beach near Asbury Park.

THE SCHUMACHER'S BEACH. In the 1880s and 1890s, the Schumacher woods and beach became a famous social place for the citizens of Clark. Many clambakes and picnic outings occurred there. Frederick Schumacher's children wanted their own beach, so he had a train car of sand brought in from the Jersey shore c. 1886. The sand was placed at the end of present-day Bartell Place on the reservoir. It was covered over in the 1907 reservoir expansion.

The Deutscher Klub of Clark. Established in Rahway on September 30, 1935, the Deutscher Klub of Clark was founded by Karl Kummer, Nick Ludwig Gassmann, William Degenhardt, Herban Klenner, Anton Horling, Hugh Mueller, William Troebling, Joseph Rack, Oscar Rudig, Bernard Hitzler, and Louis Grubel. It moved to 787 Featherbed Lane in 1950. The club has held many social and cultural events supporting the ancestry of the original German settlers in the Clark area.

Picton Station. This station was named in honor of Abel Picton Scudder, the son of Linus M. Scudder, of Scudder Schoolhouse fame. Abel was killed in a carriage accident in 1882. Constructed in 1898 along the Lehigh Valley Railroad line, it became the township's first form of public transportation. As the township grew, and the age of the automobile dawned, the station closed in 1947 and was razed in 1963. It is now Picton Park.

THE TAYLOR & BLOODGOOD FELT MILL. This was Clark's main industry outside of farming. It opened in 1770 as a gristmill, then was converted in 1847 into a felt mill by William Taylor and William Bloodgood of New York City. They were producers of fine felt and linen goods that were used for hat and glove manufacturing. The mill was located on Vreehland's Pond Road, now Valley Road.

A CLAMBAKE. The Union County Board of Chosen Freeholders and its chairman, Maj. Benjamin King, attend the annual Freeholder Clambake. This clambake was held at Bloodgood's in Clark on September 24, 1907. King also served as freeholder chairman and mayor of Clark.

THE SCUDDER SCHOOLHOUSE. Originally the site of a schoolhouse that dated back to the early settlers, the Scudder Schoolhouse was constructed in 1818. It first served Rahway's, then Clark's children as a school by day. At night, it became a community meetinghouse. Clark's first official township meeting occurred here on April 11, 1864. It was also used for many social functions. Located on the corner of Raritan Road and Central Avenue, it is the site of the present-day Rite Aid.

THE BETHLEHEM CHAPEL. Constructed in 1880, this chapel was Clark's only house of worship, serving all denominations of faith. It was destroyed by a fire in 1902, but was quickly rebuilt, as seen in this 1910 photograph. Still a part of Clark today, it serves as the Union County Baptist Church and is located on the Parkway Circle.

ROCK THE HOUSE! The rock band the Inspirations performed at Clark's first outdoor teen festival in September 1970. Sponsored by the newly formed Clark Board of Recreation Commission, the party brought over 350 youngsters to the Charles H. Brewer School. The band consisted of Jeff Grysko, Lou Perrotta, Dave Mallick, and Bob Muskus.

LOCUST GROVE GOLF COURSE, 1923. Locust Grove Golf Course, an 18-hole golf course along Lake Avenue, served the avid golfer from 1908 to 1944. It extended from Lake Avenue back to the Middlesex County line.

THE LOVERS' BRIDGE, 1900. Clark's famous Lovers' Bridge extended across the reservoir at Lambert's dairy farm and crossed over to the Schumacher's beach. It is now the Garden State Parkway bridge, which extends over the reservoir. Sitting on the Lover's Bridge is Albert Lambert.

SCHUMACHERS' HILL. Another popular site for Clark residents during the winter was Schumachers' Hill, located at the end of Riverside Drive, behind present-day Bartell Park. It served in the 1880s and 1890s as the sleighing capital of Clark Township, as seen in this 1895 photograph.

THE FARMERS' HALL. Originally located in Westfield, the Farmers' Hall was used as a Methodist church and was virtually dismantled and brought into Clark in 1901. Presently situated at 777 Raritan Road, the building served as a meeting and social place for the local farmers.

THE FARMERS' ASSOCIATION. Meeting at Farmers' Hall, the local farmers established the Farmers' Association. As an organized club, they developed into a unified group, which enabled them to market, transport, and develop their farm products.

FRANK'S WHEEL. Located at 777 Raritan Road, Frank's Wheel served as Farmers' Hall until it closed in 1940. Frank's Wheel opened in 1941 as a bar and eatery with fine dining. It was destroyed by a fire in 1963, but was rebuilt and continued in business until 1981, when its doors were closed for good. It became the Loft Restaurant in the 1980s and then a realty office for most of the 1990s. Today, it is the office of Mary P. Flanagan, D.D.S.

STRIKE UP THE BAND! Keeping the night hot was the desire of the bandleader and his dance band in this June 1944 photograph taken at Frank's Wheel.

THE HOFFMAN FOUR, PLUS ONE. During campaign season, it was common in the 1920s and 1930s to send live entertainment to local communities and buy everyone a drink to gain support for a party's candidate. As seen in this 1933 photograph, New Jersey governor Harold Hoffman had the famous Hoffman Four entertain residents at the New Deal Tavern, located on Gibson Boulevard and Emerald Place. Playing the piano and leading the tavern in song in support of Governor Hoffman is Clark Democratic committeeman Pete Keller.

THE REPUBLICAN CLUB OF 1929. Members of the Clark Republican Club gather for their victory dinner, which was held at the Farmers' Hall on November 20, 1929.

THE RAHWAY ICEHOUSE, 1901. Located on the bank of Jackson's Pond Falls, on Valley Road, was the Rahway Icehouse, which was located in Clark. In preelectric days, the frozen pond was farmed of its ice. The ice was then cut and stored to provide refreshing cool ice during the hot summer months.

THE WHITE DIAMOND. The White Diamond, a simple little eatery located at the intersection of Central Avenue and Raritan Road, has become a Clark landmark. Built in 1947, one restaurant was constructed in Clark and its twin was built on St. Georges Avenue in Roselle. The original 1947 restaurant was razed in 1995 and a new modern White Diamond replaced it. The original White Diamond is shown in this 1990 photograph by Denis E. Connell Sr.

HOWARD JOHNSON'S MOTOR LODGE. From 1961 to 1992, the Howard Johnson's Motor Lodge and Restaurant was a part of the Central Avenue landscape. From 1992 to 1993, it became the Clark Motel, only to be closed in late 1994. It was razed in 1995 for the new Shop Rite. In this 1980 photograph, the lodge is seen during its prime.

CLARK LANES. This Clark landmark stood at 142 Central Avenue from 1961 until it closed its doors in 1997. This bowling alley was the scene of many memorable occasions and 300 games for area bowlers. Currently, it is the site of Rite Aid and Bally Total Fitness center.

PROGRESS. As Clark continued to see progress with the construction of new housing developments, Clark's Westlake Homes were opened in 1932 on the new Kathryn Street along Westfield Avenue.

THE CLARK ELKS. As the township continued to experience the great migration of city residents during the 1950s and 1960s, new social clubs and civic organizations were formed. The Clark Elks Lodge 2327 opened its doors in 1965, in the old Jeney farmhouse on Featherbed Lane. This civic organization remained a part of the community until 1994, when it merged with the Mountainside Elks. The clubhouse was razed in 1995 to make way for the Pondview Estates.

ANDEL FINGERS. Constructed in 1899, this hotel was located at the intersection of Westfield Avenue and Brant Avenue. Owned by George V. Andel Fingers, it would later become the Clark Hotel, then the Ritter Hotel. Its final use was as Jack's Tavern, whose owner razed the hotel and constructed a new building at the rear of the property in 1960.

THE LOG CABIN. Russell Yarnell's Ye Olde Log Cabin was located on Palisades Avenue, presently Raritan Road. This social hall and picnic ground became the scene of many Clark organizations' social affairs. It was in operation from 1940 until it closed its doors in 1988. It was razed later that year to make room for townhouse development.

STEWART'S. During the summer of 1977, one of the more popular teenage hangouts was the Stewart's Root Beer drive-in restaurant, located at 1425 Raritan Road. Established in the 1960s, it remained a part of Clark until 1986, when it closed its doors.

CLARK ICE HOCKEY. During the 1930s, it was common for the township to sponsor a softball team or ice hockey team for the community's youth. Shown is the Clark Ice Hockey championship team of 1941. Seen here are, from left to right, the following: (first row) Emil Modal, George Lindstrom, Joe Sulo, Mike Carney, Clark Lindstrom, and Al Modla; (second row) Harold Roach, Al Nagy, George Tornroth, Tony Smolar, unidentified, Tip Flackek, John Sywec, and Ed Modla.

103

THE SODA BARN. This Clark landmark was located at 40 Gibson Boulevard. For any child of Clark who grew up in the 1950s and 1960s, it was not a Saturday morning without a trip to the Soda Barn to receive a free pretzel stick from the man with the big cigar who ran the place.

THE HOME FRONT. Clark's Hyatt roller bearing factory was the scene of a National War Bond rally in June 1943.

THE SULO WICKER FURNITURE FACTORY. This famous wicker furniture factory and outlet owned by Sylvester P. Sulo was located at the corner of Madison Hill Road and Westfield Avenue. A 1917 Hungarian immigrant, he opened this showplace and popular place of commerce during the wicker furniture craze of the 1920s. This business became so popular that Sulo moved to Rahway in 1933 to a larger building. The Sulo furniture building in Clark was razed in 1944.

INVESTING IN CLARK'S FUTURE. Mayor John O'Connor of Clark breaks ground for Clark's first official bank in March 1960. The ground-breaking ceremony took place on Raritan Road. The Clark State Bank would eventually become Fleet Bank. Today, Clark has nine banks.

THE SCHIEFERSTEIN CHILDREN AT PLAY IN 1932. Shown here are the Schieferstein children. Sitting in the tire swing is Bessie Schieferstein, on top of the tire is Jim Schieferstein, and on the swing on the right is Frederick Schieferstein Jr.

Nine
PORTRAITS OF DISTINCTION

ABRAHAM CLARK. Abraham Clark (February 15, 1726–September 15, 1794) was an American patriot known as the "Poor Man's Counselor" because he gave free legal advice to area residents of limited means. A signer of the Declaration of Independence, he was an outspoken advocate for the cause of Democratic principles and the creation of the new American nation. In 1864, the citizens of Rahway's Fifth Ward declared their independence, and renamed the area Clark Township in his honor.

EMMA TAYLOR KING. Emma Taylor King (1888–August 14, 1978) was the only daughter of Maj. Benjamin King and Dora L. Schumacher. A Clark legend, she gained fame as the Clark truant officer and helped form many of Clark's organizations. She was named citizen of the year in 1973. She is buried with her family in Hazelwood Cemetery.

CHARLES HENRY BREWER. Charles Henry Brewer came to Clark and started a farm on Raritan Road. In the 20th century, Brewer became involved in his new community and was elected township clerk. His passion was in the educational system. He served as the Clark Board of Education director, and the new middle school was named in his honor in 1949. Brewer died in 1963 at the age of 90 and is buried in Rahway Cemetery.

"Terry" Theresa M. Ward. Theresa M. Ward (December 15, 1922–January 23, 1996) was the driving force in the 1960s that led to Clark's creation of a community pool and the pool's dedication and opening in 1974. Ward was always at the pool, washing towels or checking badges. A community activist, she attended many township meetings and became a voice of the people. On January 23, 1996, while crossing Raritan Road after a Clark Republican Club meeting, she was struck and killed by a passing car.

Anthony P. Bosze. Born in Hungary in 1908, Anthony P. Bosze only lived in Clark for eight years. However, he is remembered by every baseball player in the area as the president and cofounder of Clark's Little League. Bosze created the first community ball field behind town hall on Westfield Avenue. Stricken by a heart attack, he died on March 13, 1954, and was laid to rest in St. Gertrude's Cemetery in Colonia. Bosze Field was named in his honor.

OLIVER B. RESCH. Born in 1900 in Jersey City, Oliver B. Resch and his wife, Helen, moved to 14 Wendell Place in 1938. As president of the board of education, he led the educational expansion with the addition of the Charles H. Brewer School and the new high school. As a township commissioner during the 1940s and 1950s, he was actively involved in the community. He died suddenly on May 27, 1953, after a kidney operation, and is buried in Hazelwood Cemetery.

CHARLES E. DRIESENS. Born on September 2, 1918, Charles E. Driesens and his wife, Grace, moved to 43 Prescott Turn in 1949. He was cofounder of the Clark Scholarship Fund and dedicated over 40 years to helping children seek the funding needed to attend college. He was an active member and cofounder of the Clark Public Library, the Kiwanis Club, and the Clark Elks. The Exxon chemical engineer passed away in 1997 and is buried in St. Gertrude's Cemetery in Colonia.

JAMES NELSON. Born on July 10, 1961, in New York, James Nelson and his wife, Rosanne, settled with their two daughters in Clark in 1993. The New York City Port Authority police officer quickly became involved in his new hometown. On September 11, 2001, hearing the call for help at the World Trade Center, he left his post in Jersey City and went to the trade center, where he made the supreme sacrifice.

WILLIAM B. HARRISON. While walking with his children, William B. Harrison (January 6, 1925–February 6, 1972) heard a cry for help at the Clark reservoir. Two skaters had fallen through the ice. Harrison attempted to rescue the teens. He was able to rescue 15-year-old Brian Subliskey, but as he attempted to rescue the second youth, 15-year-old Edward Milewski, both were overcome by the freezing water. Harrison's sacrifice was memorialized by the naming of the recreation center in his honor.

ARNOLD "RED" J. MORWAY. Arnold J. Morway moved to Clark in 1940 with his wife, Dorothy. Born in 1906, he was one of the most prolific inventors in the country with 816 patents to his credit. He was a member of the products research team and an engineer for Exxon. His most popular invention was Eisenhower grease, which helped waterproof U.S. military trucks, tanks, and other equipment during World War II. He retired in 1969 and remained in Clark until his death in 1985.

EDWARD S. AYERS. Edward S. Ayers (January 19, 1893–September 23, 1983) was Clark's own Benjamin Franklin. Founder of the Clark Public Library, cofounder of the Clark Historical Society, and citizen of the year in 1973, Ayers served as cochairman of the Clark Centennial Commission in 1964 and was cofounder of the U.S. Bicentennial Committee of 1976. He was the founder of the Dr. William Robinson Plantation historic site, and Ayers Lane was named in his honor in 1966.

NORMA B. DAVENPORT. Born in 1908, Norma B. Davenport was the first female candidate to run for public office in the history of Clark. Elected to the board of education in 1952, she served until 1960, when she became the councilwoman-at-large candidate on the Bill Maguire mayoral ticket. She died on December 24, 1968, and is buried in Cloverleaf Memorial Park in Woodbridge.

FRANK KRAMER HEHNLY. Born in 1899 in Clay Township, Lancaster County, Pennsylvania, Frank Kramer Hehnly was superintendent of the Clark public schools from 1935 to 1960. He oversaw the creation of the Charles H. Brewer School, the Valley Road School, and the expansion of the Abraham Clark Public School. Having retired in 1960, the Frank K. Hehnly Elementary School is named in his honor. He moved back to Ephrata, Pennsylvania, where he died on October 21, 1972.

ARTHUR LACEY JOHNSON. Born in 1879 in Standing Stone, Pennsylvania, Arthur Lacey Johnson was a descendant of the Brown family who came to America on the Mayflower. A resident of Cranford, he was an educator and served as Union County's superintendent of education. He founded the Union County Regional High School system in 1934. He died on May 15, 1955, and the new high school in Clark was named in his honor.

KATE SHAPIRO. Born in 1900 in Russia, Shapiro moved to Clark in 1924. She was the wife of Nathan Shapiro and was a leader in civic, educational, patriotic, and veterans' affairs. A 16-year member of the board of education, she also served as president and secretary. Shapiro was a founding mother of the American Legion Ladies Auxiliary. She was also considered the founding mother of Clark's high school and was the driving force to create the Valley Road School. She died on February 5, 1951, from ovarian cancer.

DR. CARL H. KUMPF. Born on February 8, 1908, in Buffalo, New York, Dr. Carl H. Kumpf came to Clark with his wife, Alma, in 1958. Kumpf became the superintendent of the Clark public schools. He helped deal with the continuing expansion of the school system. He oversaw the creation of the new Mildred Terrace Elementary School. On September 14, 1971, Kumpf passed away following a brief illness. To honor him, the Mildred Terrace School was officially renamed the Carl H. Kumpf School.

ALMAMAE D. KUMPF. Born in 1916, in Buffalo, New York, Almamae D. Kumpf and her husband came to Clark in 1958. She became active in the community, serving on various boards and community organizations. She was the first female to be officially elected to the township council, in November 1972, on the Bernie Yarusavage mayoral ticket. She was elected to a four-year term as councilwoman-at-large, but resigned from office on September 1, 1976. She died from ovarian cancer on September 12, 1976.

DAVID TOMA. David Toma (March 4, 1933–present) is a well-known inspirational speaker on the evils of drug and alcohol abuse. A Newark undercover police officer during the turbulent 1960s and 1970s his methods of undercover surveillance and use of disguises reinvented the way street police work was done. His career became immortalized through the ABC television shows *Toma*, in 1973, and *Beretta*, in 1975. He continues to reside in Clark.

THE WORM SISTERS. Elsie Worm (September 11, 1905–September 21, 1991) and Erna Worm (July 9, 1908–December 8, 1996) were the daughters of Herman Worm, an active member of the early Clark Police Department. They were considered Clark's conscience. They were regular attendees at township meetings, voicing their opinions and thoughts. Active members of the township for over 75 years in all aspects of the community, they served as Clark's grand marshals of the 125th anniversary celebration in 1989.

Ten
Fallen Heroes

Our Fallen Heroes. Shown is the Clark veterans monument, located in front of the Arthur L. Johnson High School.

CLARK SOLDIER. Shown is an 1898 Spanish-American War soldier from Clark.

CPL. JAMES BULLMAN. Cpl. James Bullman was a member of C Company, 14th Regiment, New Jersey Volunteers. This Clark hero resided on Raritan Road, where the Windsor Diner and Fleet Bank are presently located. He was killed in action in the Battle of Cold Harbor, Virginia, on June 1, 1864, along with 7,000 other Union soldiers. Bullman was one of the many Union County residents who answered President Lincoln's second call for volunteers in 1862.

JOHN B. MILLER. John B. Miller, a member of the U.S. Army, lived at 2 Valley Road. His father, Adam, received notice on December 9, 1918, that his son, reported as missing in action on October 16, 1918, was now reported to have died on November 12, 1918, of bronchial pneumonia following wounds received in action. Miller is buried with his father in his family's plot in Queens, New York.

BENNIE BIENKO. Bennie Bienko (serial No. 02245585), specialist, first class, of the U.S. Navy was killed in action on November 13, 1942, during the naval battle of Guadalcanal while aboard the USS *Monssen*. Bienko fought in the battle along with fellow Clark resident, John L Ruddy Jr. He was killed at approximately 0200 hours, 2:00 a.m., and is considered Clark's first World War II casualty. Ironically, Ruddy was killed at approximately 1100 hours, 11:00 a.m., on the same day.

PVT. CHARLES BITSKO. Pvt. Charles Bitsko (serial No. 32559648) of the U.S. Army died in the line of duty in November 1942 while aboard a troop transport ship in the Pacific. On August 21, 1944, a new bridge was named in his honor in the vicinity of his unit's camp in the South Pacific. Both of the approaches bore a sign proclaiming its name, perpetuating the cherished memory of a good soldier. Bitsko is pictured with his niece, Gerri Johansen, prior to going overseas.

PFC Paul J. Clauss. PFC Paul J. Clauss (serial No. 3224035) of the U.S. Army was killed in action by machine-gun fire on December 15, 1944, on Leyte Island, Philippines, while coming to the aid of a wounded soldier. After growing up in Elizabeth, Paul resided with his parents on Clauss Road.

Pvt. Melvyn Graves. Pvt. Melvyn Graves (serial No. 42100647) of the U.S. Army was killed in action on January 24, 1945, while serving in France. Under heavy mortar and artillery fire, he was hit in the neck by a piece of shrapnel. His father, Herman Graves, was mayor of Clark from 1927 to 1932. One month prior to his death, he wrote a Christmas Eve letter to his son, Robert, telling him he would be home for the next Christmas, and they all would be happily together again.

PVT. RUSSELL W. GREEN. Pvt. Russell W. Green (serial No. 42000833) of the U.S. Army was killed in action on April 26, 1944, while serving in the Italian theater of war. He was one of the many Americans who fought and died on Anzio Beach, Italy. Russell grew up in Linden, but is considered a Clark resident because his parents and his sister, Lorraine, moved to a house on Raritan Road prior to his death.

2D LT. ALVIN R. GROSSMAN. 2d Lt. Alvin R. Grossman (serial No. 0803810) of the U.S. Army Air Corps died in the line of duty on June 14, 1943, while conducting training exercises aboard a navigation training plane. Grossman had just earned his wings as an army pilot two weeks prior to his death. He is buried at the Oheb Sholom Cemetery on North Broad Street in Hillside.

Eugene F. Hutchinson. Eugene F. Hutchinson, a U.S. Navy torpedoman's mate, third class, was killed in action on November 7, 1944, while serving aboard the *Albacore* (SS 218). This submarine was sunk on its 11th patrol by mines off North Hokkaido Island, Japan. All hands were lost. Hutchinson grew up in Florida, but prior to shipping out, he married Clark resident Gertrude Amon and listed the Amon residence on Westfield Avenue as his home address.

Edward J. Makowski. Edward J. Makowski of the U.S. Army Air Corps (serial No. 0-751919) was killed in action on March 3, 1944, while serving as a bombardier aboard a B-24 Liberator during a combat mission over Italy. Makowski was assigned to the 14th Air Force, 450th Bomb Group, 723 Squadron.

JOSEPH G. PADUSNIAK. A U.S. Army technician, fifth grade, Joseph G. Padusniak (serial No. 32385995) was killed in action on December 18, 1944, while serving with the 99th Infantry Division at the Battle of the Bulge. Padusniak was killed along with 30,000 other American troops during that battle and is buried in St. Mary's Cemetery on Madison Hill Road in Clark.

JOHN L. RUDDY JR. A U.S. Navy specialist, second class, John L. Ruddy Jr. (serial No. 06464195) was killed in action November 13, 1942, at the naval battle of Guadalcanal while aboard the USS *Juneau*. Ruddy was killed along with 900 other sailors that day, including the five Sullivan brothers from Waterloo, Iowa. Clark's Veterans of Foreign Wars post was named after Ruddy in 1950.

CPL. MARTIN SCHMITT. Cpl. Martin Schmitt (serial No. 32594212) of the U.S. Army was killed in action on November 30, 1944, while serving with the 102nd Infantry Division near Linnoch, Germany, and was buried overseas at the American military cemetery in the Netherlands. Schmitt married Clark resident Margaret Carlson, who was his high school sweetheart. They were living on Westfield Avenue with her family across from the present-day American Legion building prior to his entry into the service.

PFC JOSEPH WITKOWSKI. Joseph Witkowski (serial No. 12203849), a private, first class, in the U.S. Army, was killed in action on July 9, 1944, while serving with the 8th Infantry Division near St. Lo, France, during the Normandy outbreak. In 1948, present-day Joseph Street was dedicated to Witkowski and Joseph Padusniak.

1st Lt. John Wilkes Jr. 1st Lt. John Wilkes Jr. of the U.S. Air Force died in service on October 9, 1958, while piloting an F100-F Super Sabre jet. Wilkes was on a routine training flight when his jet crashed in the desert near Phoenix, Arizona. He was 28 and resided at 465 Madison Hill Road. John is considered Clark's one and only known Cold War casualty.

Sp4c. Kenneth Kuspiel. Kenneth Kuspiel, a specialist, fourth class, in the U.S. Army, was killed in action on February 1, 1968, while serving in the infantry. He died as a result of multiple wounds from an exploding land mine in the vicinity of Chu Lai, Vietnam. Kuspiel graduated from Clark's Arthur L. Johnson High School in 1964 and attended Fairleigh Dickinson University. He left school in 1966 to join the army with his high school buddies. His mother, Mary, a gold star mother, still lives in Clark today.

Lt. Cpl. John P. Winters. Lt. Cpl. John P. Winters of the U.S. Marine Corps was killed in action on May 25, 1969, after being hit by fragments from a mortar shell near Cam Lo, Quang Tri Province, Vietnam. Winters was honored in 1998 when the residents of Clark dedicated a township street, Winters Court, in his name. His mother, Margaret, a gold star mother, still lives in Clark today.

Capt. Robert L. Sevell. Capt. Robert L. Sevell (serial No. 093427) of the U.S. Marine Corps was killed in action on February 28, 1968, while copiloting a Sea Knight helicopter en route to a downed aircraft near the beleaguered marine base at Khe Sanh, Vietnam. Sevell graduated from Clark's Arthur L. Johnson High School in 1961 and was the starting quarterback of the Crusader football team during his junior and senior years. Prior to entering the service, Sevell and his wife, Valerie, had a son, Bobby, who was less than a year old when his father died. Sevell's mother, Ronnie, has passed away. She was a gold star mother.

THE VETERANS DAY CEREMONY, NOVEMBER 11, 1999. Veteran Joe Rybak and Clark resident Samantha Vargas place an American flag at the monument at Arthur L. Johnson High School to honor fallen heroes.